The College History Series

THE UNIVERSITY OF
ILLINOIS AT CHICAGO

A PICTORIAL HISTORY

FRED W. BEUTTLER, MELVIN G. HOLLI, AND ROBERT V. REMINI

The College History Series

THE UNIVERSITY OF ILLINOIS AT CHICAGO

A PICTORIAL HISTORY

FRED W. BEUTTLER, MELVIN G. HOLLI, AND ROBERT V. REMINI

ARCADIA

Note: The photographs in this work are from four main collections and numerous private ones. Photographs from the UIC Library Special Collections are listed as "UIC"; those from its Office of Public Affairs are labeled "UIC OPA"; photos from its Library of the Health Sciences are cited as "UIC LHS"; and those from University Archives at the University of Illinois in Urbana-Champaign are denoted as "UIUC."

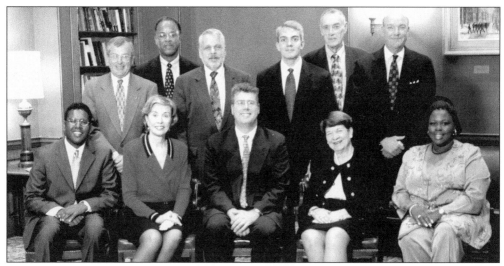

THE UNIVERSITY OF ILLINOIS BOARD OF TRUSTEES, OCTOBER 1999. Pictured from left to right are, (front row) Arun K. Reddy, UIC student trustee; Judith R. Reese; Jeffery Gindorf, M.D., chair; Susan L. Gravenhorst; and Melissa R. Neely, UIS student trustee; (back row) William D. Engelbrecht; Roger L. Plummer; Kenneth D. Schmidt, M.D.; David J. Cocagne, UIUC student trustee; Gerald W. Shea; and Thomas R. Lamont. Not pictured: Martha R. O'Malley.

CONTENTS

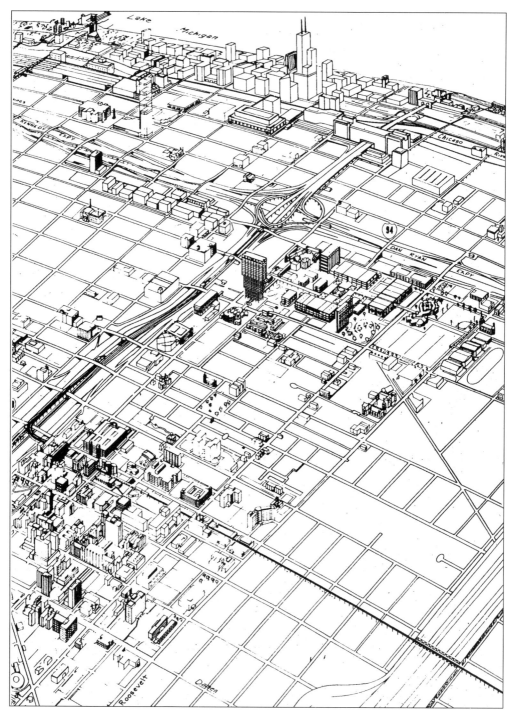

Map of UIC Campus. This map of the UIC campus presents an imaginary view from about 10,000 feet in the air, looking toward Chicago's Loop from the southwest. At the lower left is the "West Campus" of the Health Sciences, and approximately one mile from that, in the center, is the "East Campus." (Map by Raymond Brod, UIC cartographer.)

FOREWORD

The University of Illinois serves the world in countless ways, and this pictorial history of our vital and vibrant Chicago campus illustrates a few of them. You will find in these pages, and in almost two hundred historic photographs, the rich record of a campus that began as a medical school in the late nineteenth century. Today, as a comprehensive research university with 15 colleges located in a prominent urban setting, the campus is the largest and most diverse in the Chicago area, serving students from around the world.

The University's first campus, founded downstate as a land-grant institution under the Morrill Act, passed by Congress in 1862, is known today as the University of Illinois at Urbana-Champaign. In the twentieth century, the University added two campuses, the University of Illinois at Chicago and the University of Illinois at Springfield.

The University of Illinois at Chicago has grown to around 25,000 students, with 12,000 faculty and staff, and is one of the 88 largest research universities in the nation. It offers bachelor's, master's, and doctoral degree programs in more than 230 disciplines.

I trust these pictures will provide you with a better understanding of, and appreciation for, UIC's rich and varied history.

—University of Illinois President James Stuke

CHRONOLOGY

1859 Chicago College of Pharmacy established
1862 Passage of Morrill Act in Congress, creating land-grant university system
1867 University of Illinois founded in Urbana as the "Illinois Industrial University"
1882 College of Physicians and Surgeons opens with one hundred students
1891 Founding of the Columbian College of Dentistry, later U of I College of Dentistry
1896 Chicago College of Pharmacy merges with University of Illinois
1897 Affiliation of Physicians and Surgeons with the university as its Department of Medicine
1913 Full incorporation of Physicians and Surgeons into university as its College of Medicine
1919 Affiliation with new Illinois Department of Public Welfare to create
 "Research and Education" Hospitals on Chicago's West Side
1937 Dedication of the East Tower for Dentistry, Medicine, and Pharmacy
1941 Illinois General Assembly creates Medical Center District
1946 Chicago Undergraduate Division on Navy Pier established
 George Stoddard becomes U of I president
1951 Illinois General Assembly directs university to create permanent Chicago branch
1953 George Stoddard resigns
1955 David Dodds Henry appointed U of I president
1956 U of I Trustees select Miller Meadows as site for Chicago campus
1959 School of Nursing (established 1951) becomes the College of Nursing
1960 Mayor Richard J. Daley offers Congress Circle site to trustees
 Passage of Universities Bond Issue, providing funds for Chicago campus
1965 Opening of Circle Campus in February; with 8600 students by fall quarter
1966 Norman Parker becomes chancellor of Circle Campus
 Joseph Begando becomes chancellor of Medical Center
1967 University's Centennial Year Celebration; first commencement of UICC
1971 John Corbally appointed U of I president; Warren Cheston becomes UICC chancellor
1975 Donald Riddle becomes UICC chancellor
1976 Groundbreaking for new U of I Hospital
1979 Stanley Ikenberry appointed U of I president
1982 Consolidation of UICC and UIMC to form University of Illinois at Chicago
 Donald Langenberg named first UIC chancellor
1988 Opening of first Student Resident Halls, East Campus
1991 James Stukel appointed UIC chancellor
1995 James Stukel becomes U of I president; David Broski named UIC chancellor
1999 Sylvia Manning named interim UIC chancellor
2000 Ground-breaking on South Campus Development Project

INTRODUCTION

The University of Illinois at Chicago (UIC) has had an extraordinary history, for in a very real sense it evolved out of the perceived needs of the people of Illinois. Historically, different aspects of its tripartite mission of Research, Teaching, and Service have been emphasized during key transition periods. Founded in 1867, the university expanded into Chicago in the 1890s, affiliating itself with several private medical colleges in pharmacy, medicine, and dentistry. By 1913, all of these colleges had been fully incorporated into the university, which later added other health science colleges. In the early 1950s, the health sciences emphasized teaching, and the College of Medicine expanded into the largest medical school in the country. During the 1980s, a stronger emphasis was placed upon research, which helped UIC emerge as a Carnegie Research 1 institution.

University undergraduate instruction in Chicago began as a result of the passage of the G.I. Bill in 1944, which enabled returning veterans to obtain an education at virtually government expense. The University of Illinois pledged to admit all qualified students. To meet the staggering demand, it established two two-year branch campuses at Chicago's Navy Pier and at Galesburg, where students could take required courses before completing their studies in Urbana. Almost immediately, Chicagoans called for expansion, and under the inspired leadership of Mayor Richard J. Daley, the Circle Campus was created and located in 1965 on the near west side of Chicago, in the historic Hull-House neighborhood.

As a two-year branch, Navy Pier enjoyed a long tradition of committed undergraduate teaching, which continued at Circle Campus. Many early faculty, however, had been recruited to Circle because of its connection to a strong research university, and they expected Circle to rapidly develop into a research-oriented school emphasizing graduate instruction. In 1982, Circle Campus joined with the Medical Center to form the University of Illinois at Chicago, and this consolidation brought important changes. With outreach programs coordinated in the Great Cities Initiative, the university recognized its urban location as a major strength. Over the last decade, UIC has helped to develop a new model of higher education: the comprehensive urban research university.

In compiling these photographs, we sought to convey this sense of institutional purpose that we see UIC developing. We have made a serious effort to balance the various elements of UIC's history. In many ways, our most difficult task in this pictorial history was selection: it was simply not possible to include each department and each college that have contributed to UIC. As such, this is a pictorial introduction, the first project from the Office of the UIC Historian, which is currently in the process of researching and writing a comprehensive history of UIC in its relation to the city, the state, and the nation.

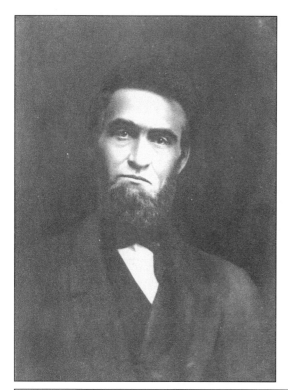

Jonathan Baldwin Turner, an agricultural scientist and farmer from Jacksonville, Illinois, lobbied tirelessly for federal legislation to create state land-grant universities, which eventually became the Morrill Act of 1862. Turner was an ardent supporter of agricultural and technical education, and was instrumental in the drive to create a University of Illinois. (UIUC.)

Shown here is the University of Illinois in Urbana in 1874. The view is from University Hall, looking north across Green Street and the Boneyard Creek. (UIUC.)

10

One

UNIVERSITY
ADMINISTRATION
1867–1946

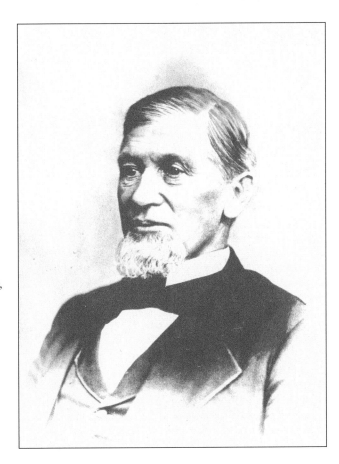

John Milton Gregory served as the first Regent of the University, from 1867 until 1880. Gregory interpreted the Land-Grant act broadly, allowing the inclusion of the liberal arts and the humanities into the curriculum, which elicited strenuous protests from those who intended the university to offer only practical classes in agriculture and the "mechanic arts." (UIUC.)

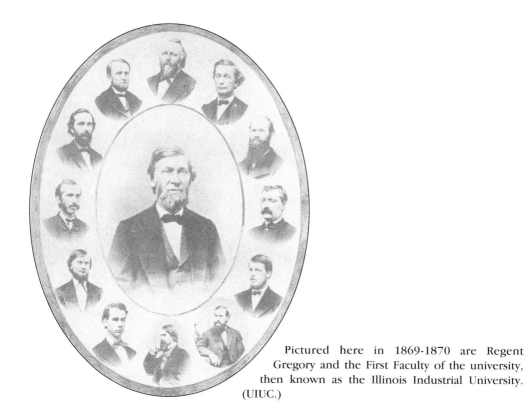

Pictured here in 1869-1870 are Regent Gregory and the First Faculty of the university, then known as the Illinois Industrial University. (UIUC.)

Regent Selim Hobart Peabody, 1880-91, shared Gregory's commitment to the liberal arts, although the continuing effects of the Panic of 1873, combined with legislative indifference, led to difficult financial times for the university. In addition to faculty pay cuts and increased tuition, Peabody promoted many restrictive policies, including daily chapel attendance, military training, and the prohibition of student fraternities. As a result, Peabody fell victim to numerous student pranks, such as gluing his Bible shut, which he was to read for chapel service, and rigging the webbing of his chair so it would collapse as he sat down. (UIUC.)

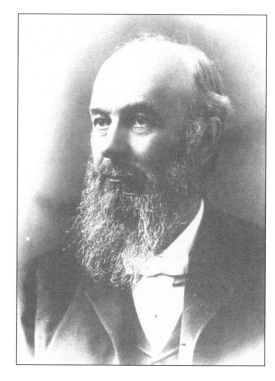

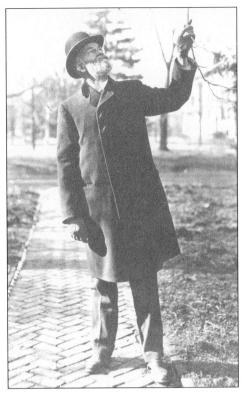

Thomas Jonathan Burrill, a university botany professor, served as Acting Regent from 1891 to 1894. He reformed the office of Regent and sought to address student grievances, in addition to raising faculty pay, and initiating tenure and the sabbatical. He formalized enrollment and also set the stage for the formation of the Graduate College, University Extension, and Summer Session. (UIUC.)

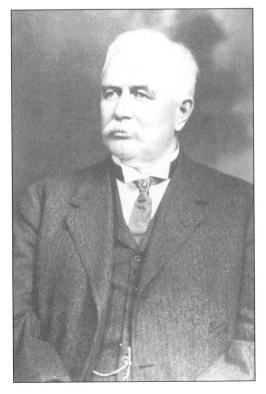

The first executive to hold the title of President was Andrew Sloan Draper, who served from 1894 to 1904. During Draper's administration, the Chicago-based College of Physicians and Surgeons, a college of Dentistry, and the Chicago College of Pharmacy affiliated with the university. In addition, the university began a law school, and reached parity with the Universities of Wisconsin and Michigan in student enrollment and physical plant. (UIUC.)

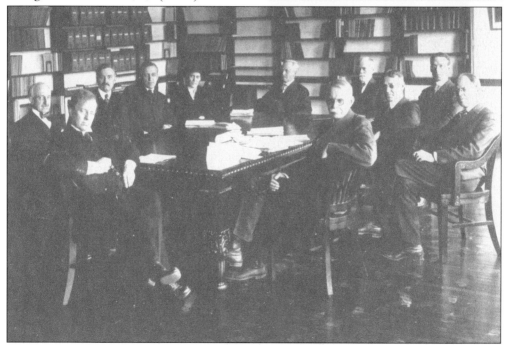

Edmund James left the presidency of Northwestern to become Illinois's president in 1904, serving until 1920. A figure of national prominence, James sought to increase the university's stature through the expansion of faculty, which reached to nearly one thousand. In addition, James stabilized the Chicago professional colleges, and formally incorporated the College of Physicians and Surgeons as the university's College of Medicine in 1913. (UIUC.)

During the James era, the Council of Administration served as the president's cabinet in a period of massive expansion. The Chicago professional colleges were represented by Dean Albert Eycleshymer of the College of Medicine, Dean Frederick Moorehead of the College of Dentistry, and William Day, actuary of the College of Pharmacy. (UIUC.)

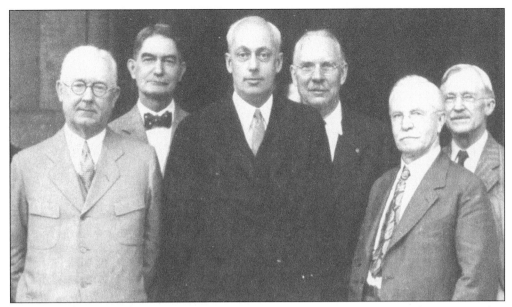

President David Kinley, right foreground, assumed the presidency in 1920, having served in various academic and administration roles since 1893. Kinley established sound budget practices and long-range planning, and moved the Chicago colleges to their present location along Polk street. He was succeeded in 1930 by Harry Woodburn Chase, in the dark suit, center. Chase served only until 1933, when budgetary difficulties caused by the Great Depression led to his dismissal. Arthur Hills Daniels, not pictured, served as acting president until 1934. (UIUC.)

Arthur Cutts Willard, a mechanical engineering professor, took office in 1934, during the depths of the Depression. Willard utilized federal money to fund campus expansion, with the New Deal underwriting major building projects at the Chicago medical center. World War II expanded federal research funding, as the University contracted with the federal government for defense related research. Willard retired in 1946. (UIUC.)

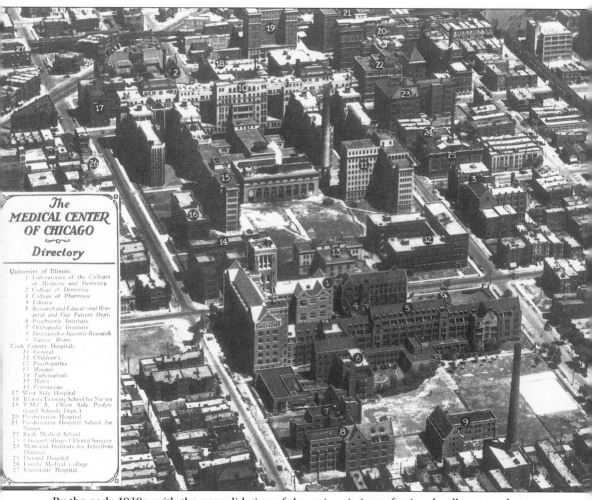

The
**MEDICAL CENTER
OF CHICAGO**

Directory

University of Illinois:
 1 *Laboratories of the Colleges
 of Medicine and Dentistry*
 2 *College of Dentistry*
 3 *College of Pharmacy*
 4 *Library*
 5 *Research and Educational Hos-
 pital and Out Patient Dept.*
 6 *Psychiatric Institute*
 7 *Orthopedic Institute*
 8 *Institute for Juvenile Research*
 9 *Nurses' Home*
Cook County Hospital:
 10 *General*
 11 *Children's*
 12 *Psychopathic*
 13 *Morgue*
 14 *Tuberculosis*
 15 *Men's*
 16 *Contagious*
 17 West Side Hospital
 18 Illinois Training School for Nurses
 19 Y.M.C.A. (West Side Profes-
 sional Schools Dept.)
 20 Presbyterian Hospital
 21 Presbyterian Hospital School for
 Nurses
 22 Rush Medical School
 23 Chicago College of Dental Surgery
 24 Memorial Institute for Infectious
 Diseases
 25 Durand Hospital
 26 Loyola Medical College
 27 University Hospital

By the early 1930s, with the consolidation of the university's professional colleges on the near west side, Chicago was home to one of the world's largest concentrations of medical institutions, including the university, Rush Medical School, St. Luke's Presbyterian Hospital, and Cook County Hospital. In 1941, the state legislature created the Illinois Medical District, which had as its mandate the coordination of medical training, patient care, and research. The colleges of Dentistry, Medicine, and Pharmacy moved into their new building (opposite) in the mid 1930s. (UIC LHS.)

Two

HEALTH SCIENCES

1850s–1982

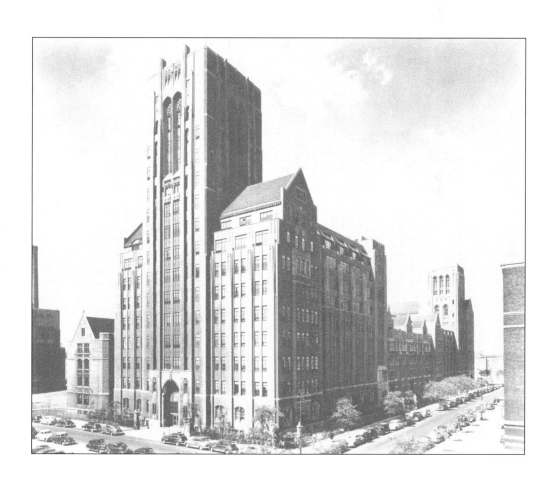

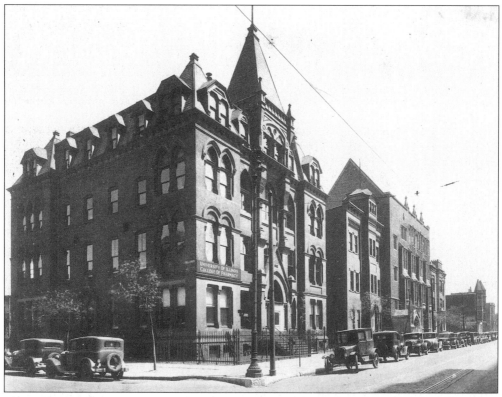

The earliest academic unit of the university was the College of Pharmacy, founded as the Chicago College of Pharmacy in 1859. The college closed during the Civil War, reopened in 1870, but closed the following year due to the Chicago Fire. The college affiliated with the University of Illinois in 1896 as its School of Pharmacy. Pictured above is the 701 S. Wood Street building, which housed the college from 1916 to 1939. The title above is from the 1924 yearbook, the *Illio*. (UIC LHS.)

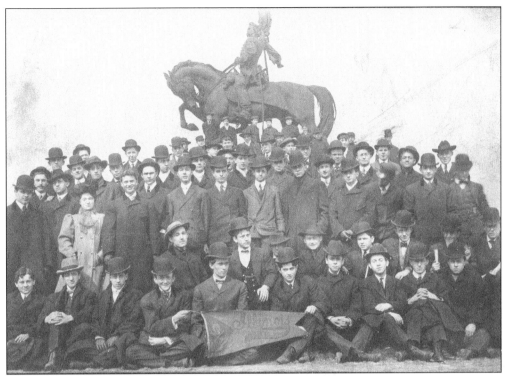

Pharmacy's class of '06, posing for their junior class picture in front of General Logan's statue in Chicago's Grant Park. Note the "Illinois Pharmacy" pennant with skull and crossbones. (Courtesy of College of Pharmacy.)

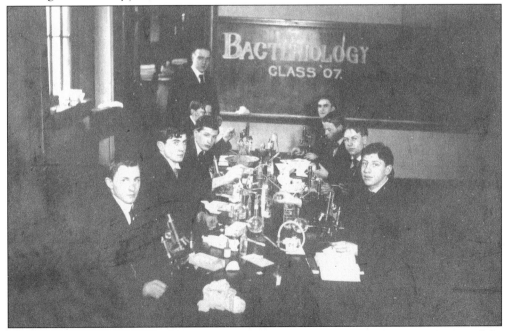

At its founding, the Chicago College of Pharmacy was the only pharmacy school west of the Alleghenies, and had a strong emphasis upon laboratory instruction and research.

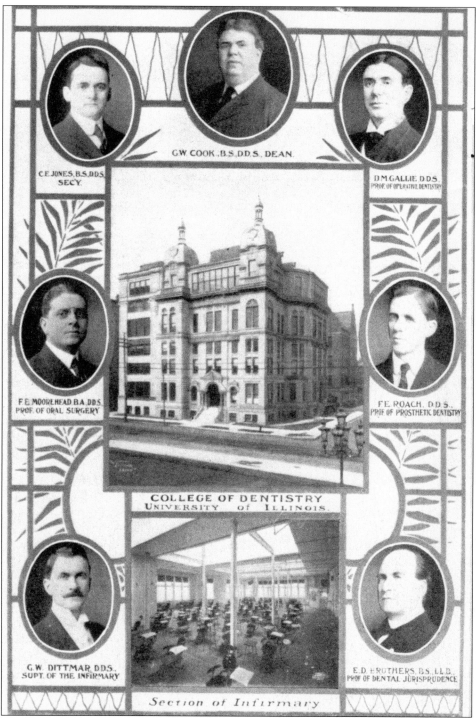

The College of Dentistry evolved from the Columbian College of Dentistry, founded in 1891. After financial difficulties and several reorganizations, it became part of the College of Physicians and Surgeons in 1901. It retained a nominal affiliation with the University until 1913. Above is a promotional brochure with the staff of the College of Dentistry, 1909.

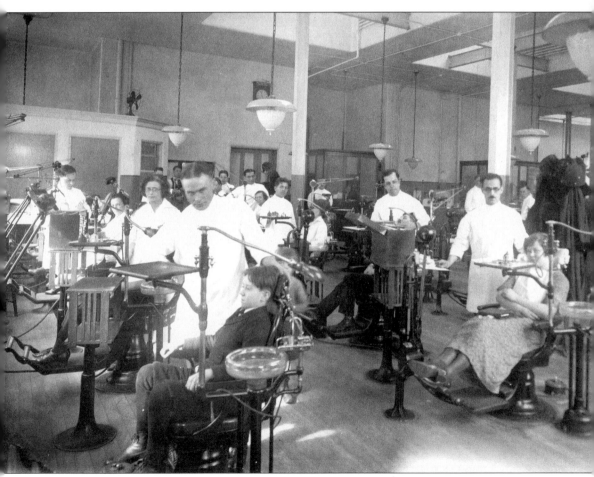

Upon full incorporation into the university, the College of Dentistry purchased new equipment, making it the first institution in the country to have all electric-driven drills, although the state licensing exam required foot-powered drills for many years thereafter. The Dentistry title above is from the 1924 *Illio*. (Courtesy of Dr. Eisenmann.)

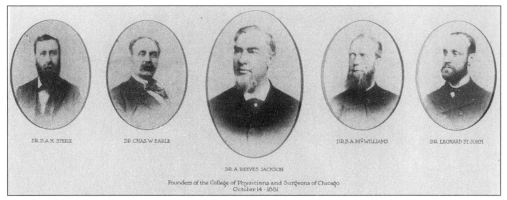

The College of Physicians and Surgeons was founded as a proprietary college in 1882. Prospective students needed to be only eighteen years old and of "good moral character" to study medicine. (UIC LHS.)

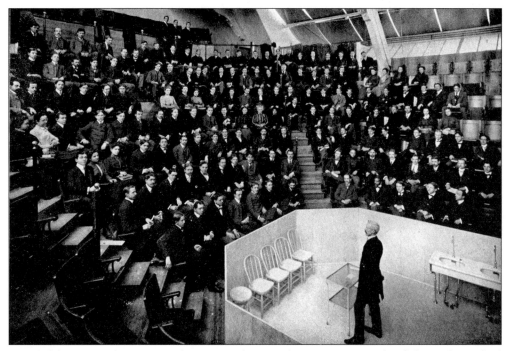

Pictured here is a Physicians and Surgeons lecture class in 1903. Much of the early medical curriculum consisted of didactic lectures, with only limited laboratory and clinical instruction. (UIC LHS.)

COLLEGE OF
PHYSICIANS AND
SURGEONS

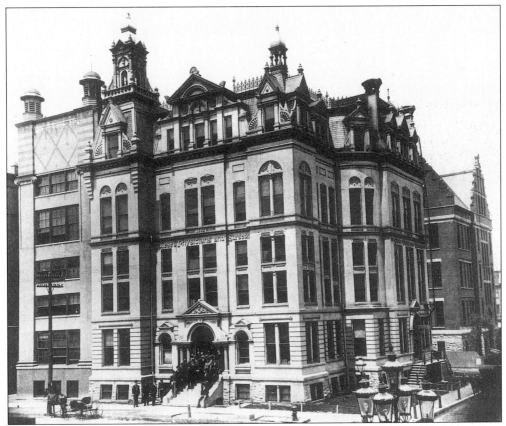

Here, the faculty poses on the steps of the College of Physicians and Surgeons, located at the corner of Harrison and Honore, across the street from Cook County Hospital. Affiliated with Physicians and Surgeons was the West Side Hospital, adjacent to this building, which served as the basis for clinical training. (UIC LHS.)

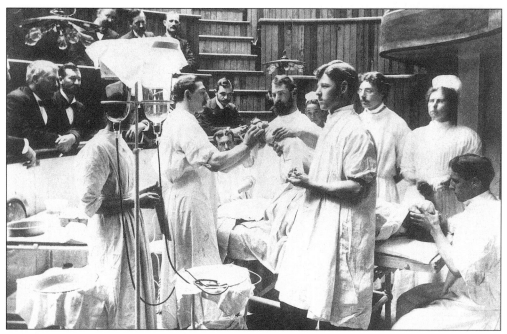

Performing the amputation of a foot in the Beck Surgical Clinic in 1910 are Carl Beck and his brother Joseph (with beard), as well as Alexis Carrel, who in 1912 received the Nobel prize for his work on vascular structure and the transplantation of blood vessels. (UIC LHS.)

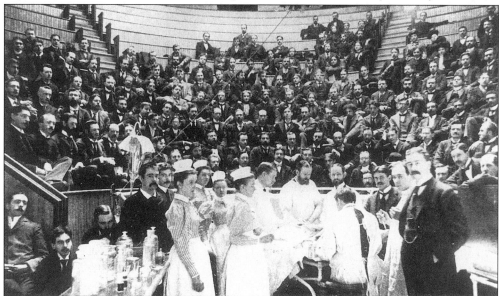

Shown here in 1898 is Physicians and Surgeons Professor J. B. Murphy's clinic at Cook County Hospital. Dr. Murphy (with beard at operating table) was one of the greatest surgeons of his era, having first gained fame for treating some of the victims of the Haymarket bombing in 1886. He developed many advanced surgical techniques and also invented the famous "Murphy button," which revolutionized intestinal surgery. Murphy taught at P&S from 1892 until 1901, when he left to expand his clinic at Chicago's Mercy Hospital. Murphy would later remove the bullet from Theodore Roosevelt, after the failed assassination attempt in 1912. (UIC LHS.)

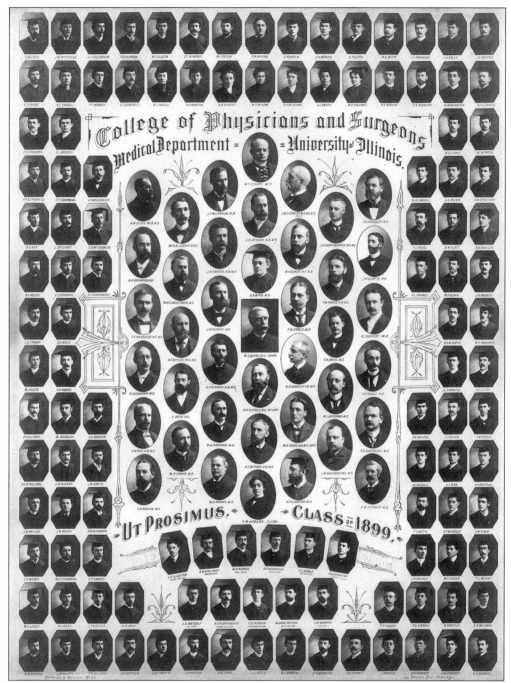

P&S expanded rapidly in the 1890s, purchasing the West Side Hospital in 1896, and affiliating with the University of Illinois in 1897. Between 1895 and 1901, enrollment at P&S exploded from 235 students to 710. In 1900, the college purchased the West Division High School to provide space for medical instruction, and to end what Dean William Quine called the "disgraceful fraternization" between the P&S students and those at the high school. (UIUC.)

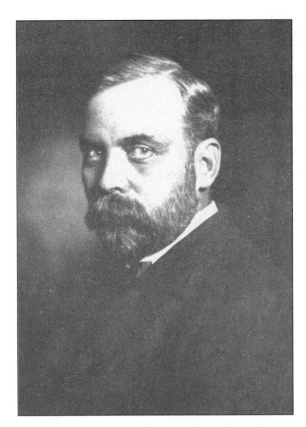

Chicago physician Bayard Holmes became educational director and corresponding secretary of the P&S in 1891, as the college teetered near bankruptcy. A former P&S student who possessed both regular as well as homeopathic MD's, Holmes admitted homeopathic students, which was quite controversial, but which boosted P&S enrollment, thereby providing needed income. Holmes also added bacteriology and lab classes, opposite top, as an essential part of the P&S curriculum. (UIC LHS.)

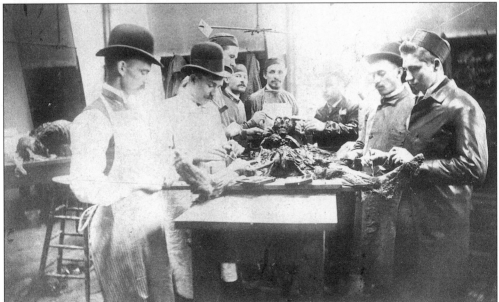

Hard at work is a P&S anatomy class in the late 1880s. In 1883, the P&S required that each student gain experience with "dissection of each part of the cadaver," as a condition for graduation. Due to the scarcity of anatomical material, however, many students frequently worked on the same body. Shown at right is the young Professor Ralph Whitehead. (UIC LHS.)

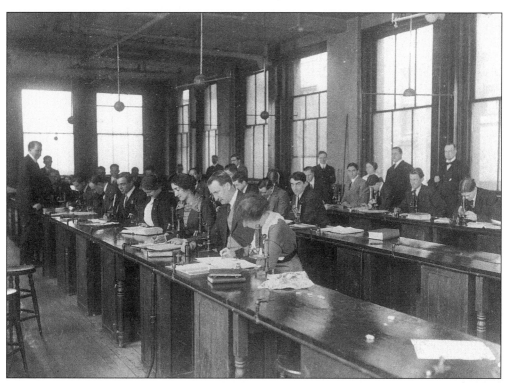

Dr. William E. Quine, seen in this student sketch, was an early member of the P&S faculty who for thirty years played an instrumental role in the life of the college, serving as "dean" from 1891 to 1914. Quine donated generously from his own successful practice to underwrite P&S during its initial shaky years. Quine raised admission standards, and helped found the college library, which was later named in his honor. (UIC LHS.)

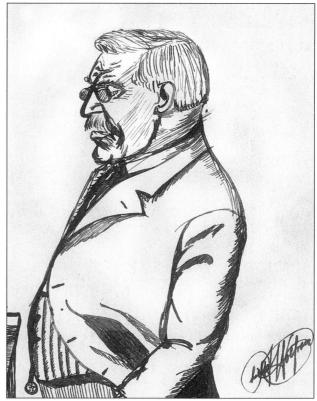

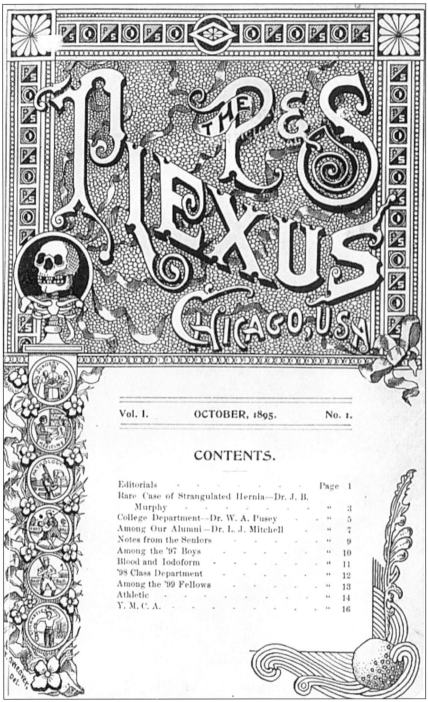

Vol. I. OCTOBER, 1895. No. 1.

CONTENTS.

The first issue of *The P&S Plexus,* the student-run monthly, contained commentary on medical and social issues, as well as poetry, stories, and cartoons. During its seventeen- year run, *The Plexus* gained favorable mention in the nation's medical press. Note the medallions along the left side, which give the full range of student interests at P&S: "Surgery," "Medicine," "Pathology," "Football," "Baseball," and "Gymnastics." (UIC LHS.)

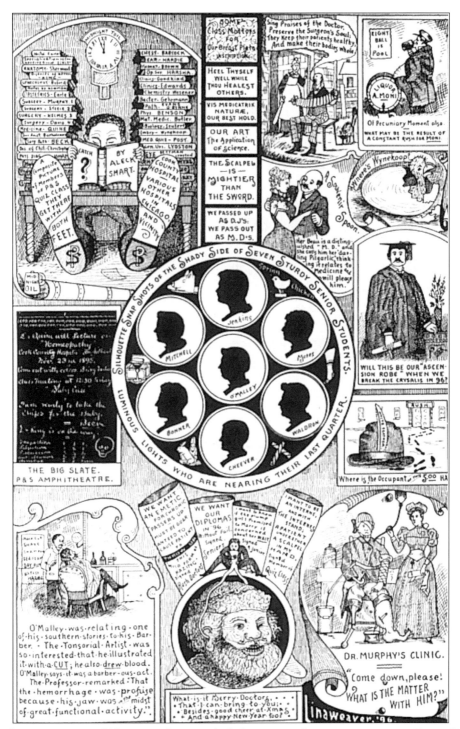

The first two issues of *The P&S Plexus* included cartoons from A. Linaweaver, Class of '96, honoring and satirizing fellow students and professors. Unfortunately, after the first two issues, the faculty asserted a stronger hand, and the journal became more focused on exclusively medical concerns. Note "Dr. Murphy's Clinic," lower right. (UIC LHS.)

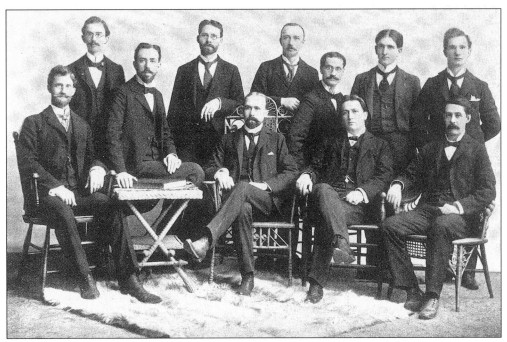

To the right of *P&S Plexus* editor Rodney Smith (center, with beard) sits Professor W. A. Pusey, the journal's faculty representative, in 1896. (UIC LHS.)

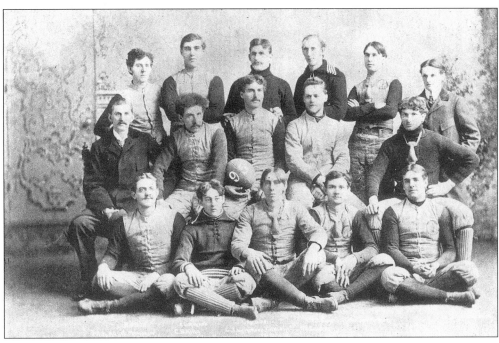

The chant for the P&S football team (pictured in 1895) emphasized their curious colors: "Hail to the colors of dear P&S/ Three cheers for Blood and Iodoform./ Hail to the College, the people shall bless./ Three cheers for the Blood and Iodoform." Iodoform is a yellow-brown color, similar to iodine. (UIC LHS.)

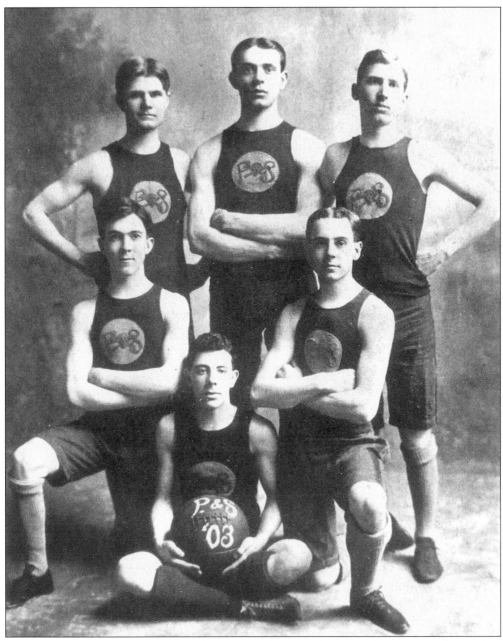

Although a school of professional medicine, the College of Physicians and Surgeons featured an active student body that eagerly participated in a wide array of activities, including intercollegiate athletics. Pictured here is the P&S Basketball team of 1903. (UIC LHS.)

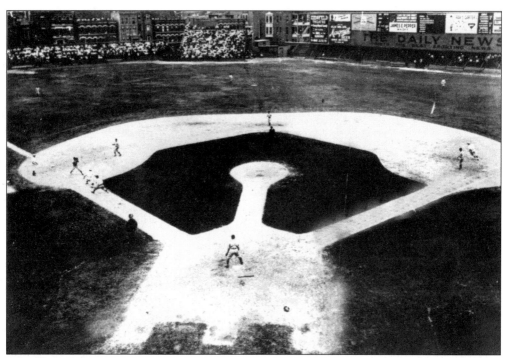

Between 1893 and 1916, the West Side field was home to the Chicago White Stockings, later the Cubs. The double play was perfected here by the team of "Tinkers to Evers to Chance." The university purchased the property in order to consolidate its professional colleges and expand its medical education. The west tower of the new medical building was constructed on the approximate site of home plate. (Courtesy of Near West Side Project.)

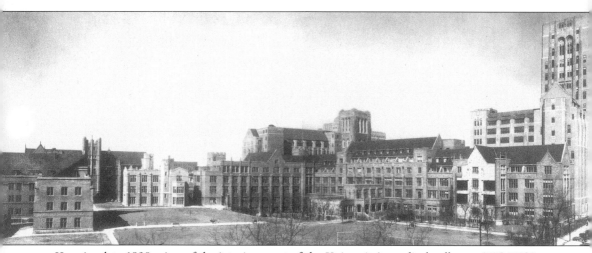

Here is a late 1930s view of the interior court of the University's medical colleges. (UIC LHS.)

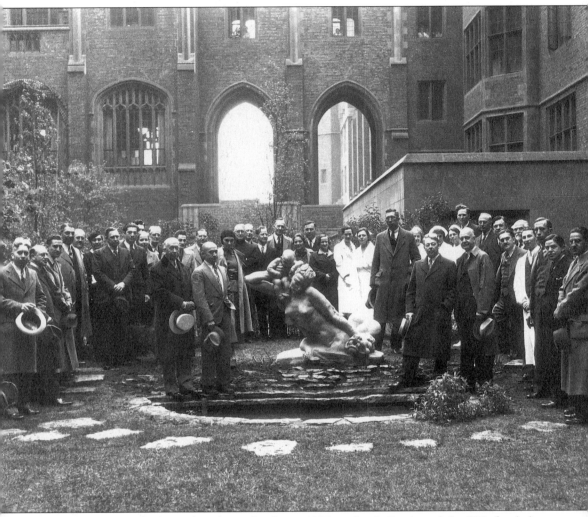

Shown here is the College of Medicine faculty in 1937 at the dedication of the WPA funded statue, "The Spirit of Medicine Warding off Disease," by Olga and Edouard Chassaing, in the quadrangle of the College of Medicine. In the right foreground is College of Medicine Dean David John Davis, with straw hat. (UIC LHS.)

The women students of the College of Pharmacy pose for a photograph, *c.* 1930. (UIUC.)

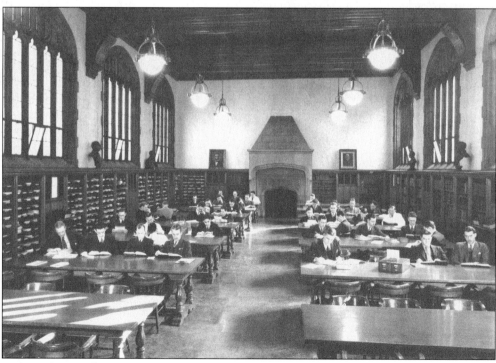

Dedicated in 1924, the Quine Library in the College of Medicine served dentistry, medicine, and pharmacy students, and currently serves as the faculty lounge. (UIUC.)

34

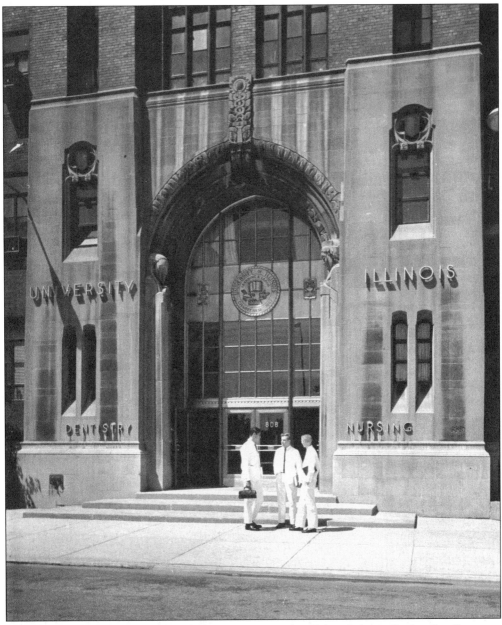

Pictured here in the early 1950s is the entrance to the University's professional colleges, as represented by the three major colleges: dentistry, medicine, and pharmacy. (UIUC.)

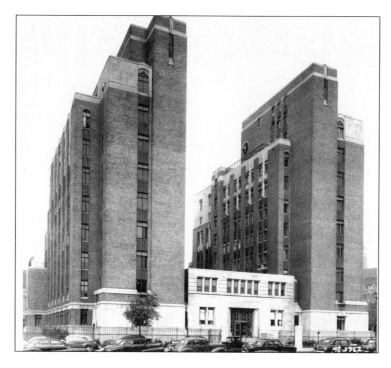

The Illinois Neuropsychiatric Institute opened in 1940 as the "first institute in the world completely equipped under one roof to investigate and treat all neurological and psychiatric diseases." The building was constructed to symbolize the brain's hemispheres, with the North Tower (right) housing the Department of Neurology and Neurosurgery, and the South Tower the Department of Psychiatry. (UIUC.)

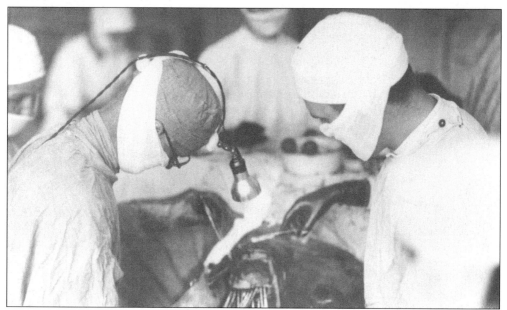

Harvard's Harvey Cushing, left, a founder of modern neurosurgery, trained several U of I surgeons, including Eric Oldberg, right, who became the first director of Illinois's Department of Neurology and Neurosurgery. (Courtesy of Dr. Boshes.)

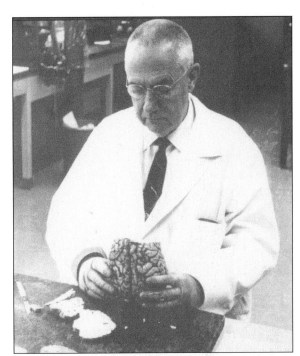

Dr. Perceival Bailey, a neurosurgeon who was also trained in psychiatry, pioneered a body of research on the brain, and led a team that constructed cytoarchitectonic maps of the cerebral cortex. (Courtesy of Dr. Boshes.)

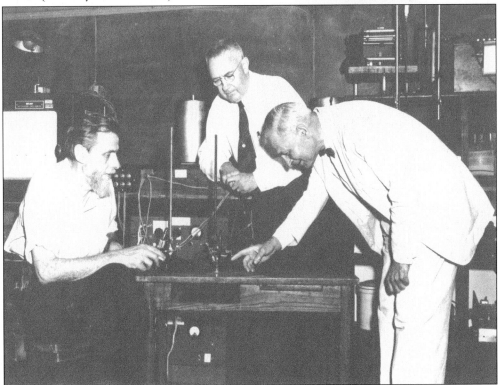

Pictured left to right are: Dr. Warren McCullough, Dr. Perceival Bailey, and Dr. Gerhart von Bonim. Dr. McCullough was the first research director of the Neuropsychiatric Institute, which concentrated on mathematical representations of neural networks. (Courtesy of Dr. Boshes.)

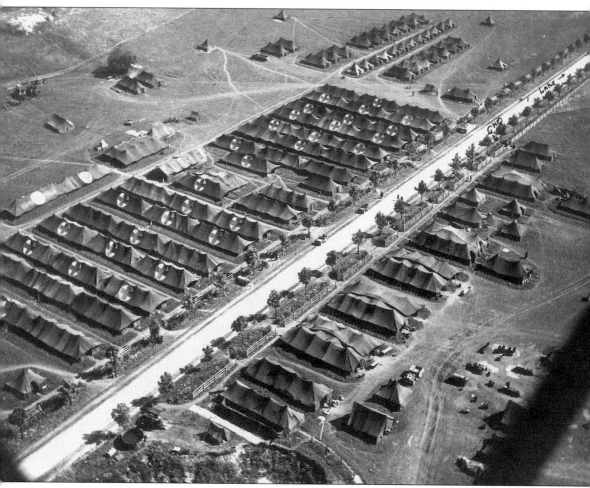

During World War II, the University formed the 27th Evacuation Hospital, shown above encamped in southern Germany. The 27th Evac. served in North Africa and Italy, and landed in Southern France, before following the Ninth Army into Germany. After the war, the University continued in defense-related research such as studies of nitrogen elimination at 38,000 feet, simulated in the Aeromedical research lab, opposite top right. Below it is the famous Warburg apparatus, used to study the metabolism of brain tissue, in the Department of Psychiatry, 1948. (All photographs courtesy of UIUC.)

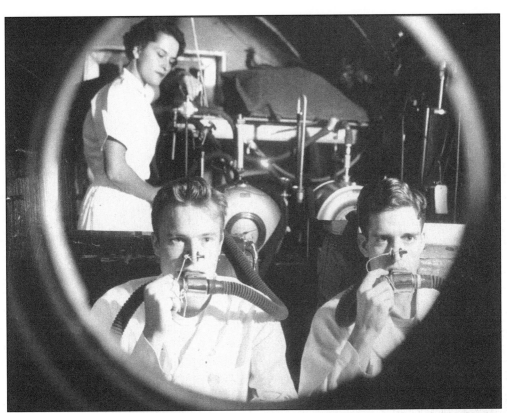

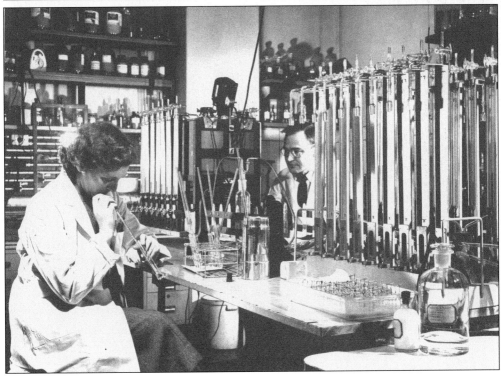

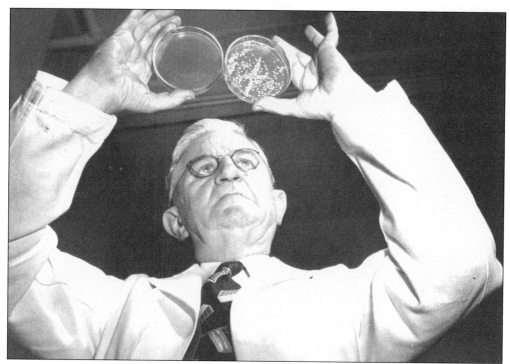

College of Dentistry researcher Dr. Joseph F. O'Donnell demonstrates the results of an experiment involving substances to inhibit tooth decay in 1948.

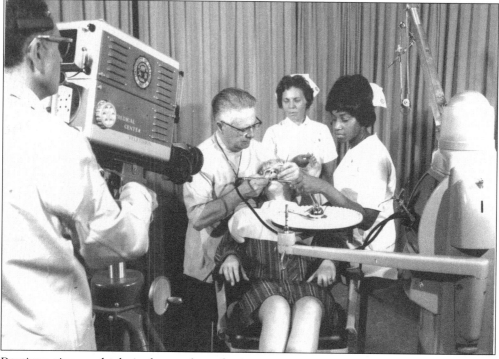

Dentistry pioneered televised procedures for its extension program, as seen here in the early 1960s. (All photographs courtesy of UIUC.)

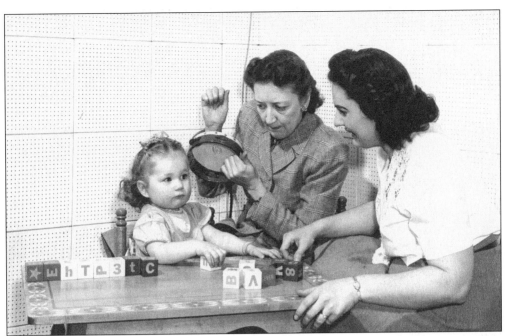

The Chicago Professional Colleges were active throughout Illinois in various extension services, such as the testing of hearing-impaired children, in Springfield, Illinois.

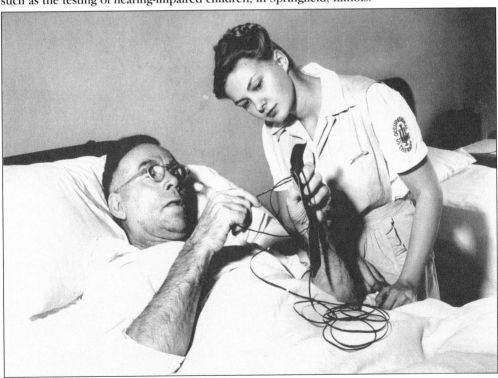

The College of Medicine was the first in the country to establish an Occupational Therapy program. Here, student June Fluegge helps a patient in the Research and Education Hospital make a purse.

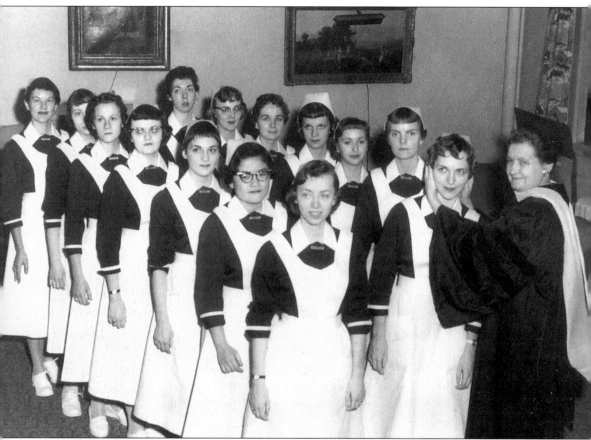

Sophomore nursing school students undergo their "capping" ceremony in January of 1959. Anne Palmer, among others, received the nurses cap from the Dean of the College of Nursing, Emily C. Cardew. The School of Nursing was created in 1951 as an autonomous unit, and a four-year degree program was approved two years later. In 1959, the School was elevated to a College, and graduate study in nursing began in 1962. In the 1970s, the College of Nursing expanded to include sites in Urbana, Peoria, and Rockford, and in 1974 established the first Ph.D. program in nursing in Illinois. (UIC LHS.)

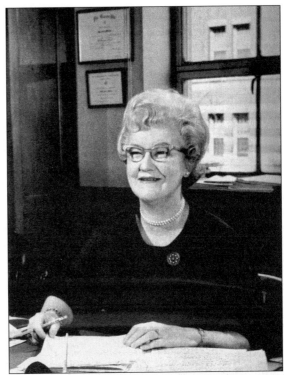

Dean Mary K. Mullane led the College of Nursing from 1962 to 1971, overseeing extensive growth. Considered the most influential person in the history of the College, she help gain national recognition for the college and laid the foundation for doctoral training in Nursing. (Courtesy of UIC Alumni Association.)

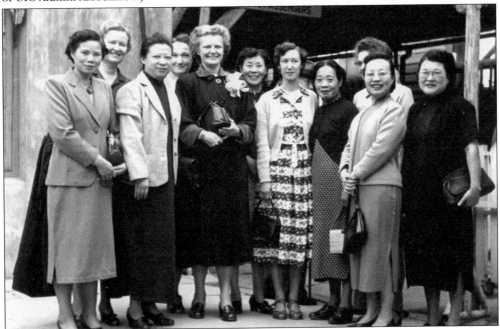

Virginia Mae Ohlson, in dark coat with corsage, trained Japanese nurses with the Atomic Bomb Casualty Commission in Japan during the Occupation, and later became head of the Department of Public Health Nursing in the College of Medicine. Ohlson continued her work in international health, bringing numerous Asian students to study at the College of Nursing. (Courtesy of Midwest Nursing Resource Center.)

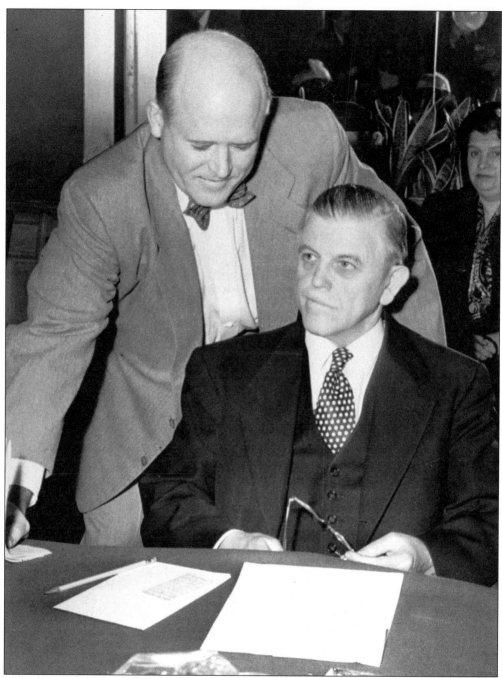

In 1946, Dr. Andrew C. Ivy, seen here with Trustee Park Livingston (left), became Vice President of the Chicago Professional Colleges. Ivy was a prominent medical researcher, serving as a consultant for the Nuremberg trials. Five years later, he went public with a supposed cancer cure, "Krebiozen," prior to outside testing of the drug, which later led to hearings in front of the Illinois legislature, as seen in this picture from December of 1952. The Krebiozen controversy severely damaged the College of Medicine, and was a factor in President Stoddard's resignation. (UIUC.)

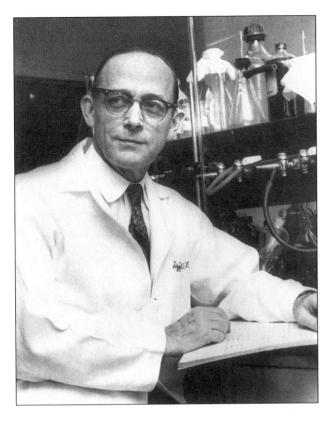

Dr. Warren Cole served as head of the Department of Surgery from 1936 until his retirement in 1966. The first full-time head of a clinical department in the United States, Cole concentrated on basic clinical research, publishing over 350 scientific articles and thirteen books, and personally training more than seventy surgeons. (UIC LHS.)

Seeking to rebuild the college after the resignations of numerous heads due to the Krebiozen controversy, pathologist Granville Bennett assumed the deanship of the College of Medicine in the wake of the Ivy scandal. Bennett led the College from 1954 through 1967, reestablishing its reputation. (Courtesy of UIC Alumni Association.)

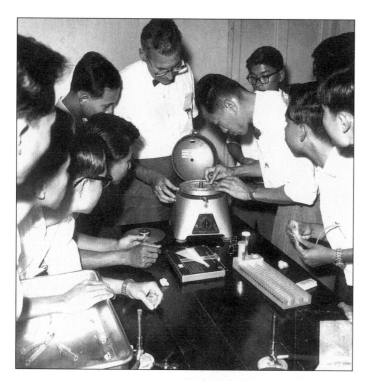

With funding provided by the government of Thailand and US AID, the University Medical Center began the 1961 Chiang Mai Project, which sought to improve public health programs by developing a microbiology department for the Chiang Mai Hospital. (UIC.)

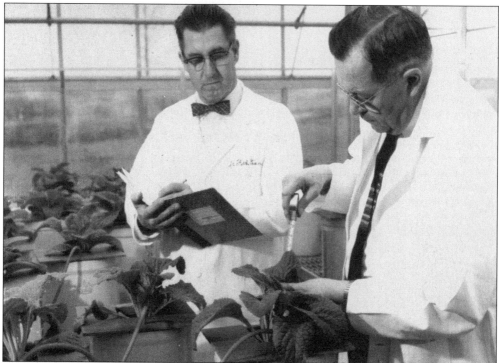

Dr. Frank Crane, left, records data on plant growth with Dr. Ralph Voigt, head of pharmacognosy and pharmacology, at the College of Pharmacy's experimental greenhouse in Downers Grove, Illinois, in the late 1950s. (UIUC.)

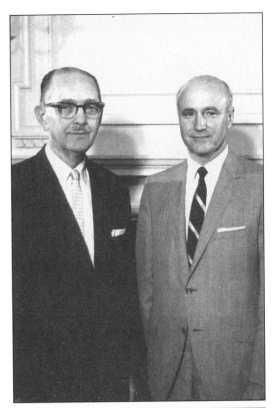

In 1960, President David Henry, left, appointed economist Joseph Begando vice-president of the Chicago Professional Colleges. Begando later became the chancellor of the U of I at the Medical Center. He served from 1960 until retirement in 1983, and under his administration the Medical Center became one of the largest health science centers in the world. (UIC LHS.)

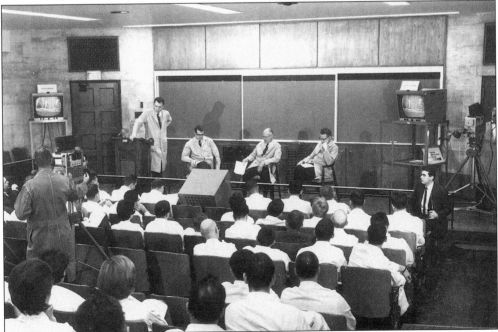

The Medical Center was a leader in innovative teleconferencing, and by the early 1960s had closed circuit capability with other university departments. The placards on the television monitors read, "From Urbana." (UIC LHS.)

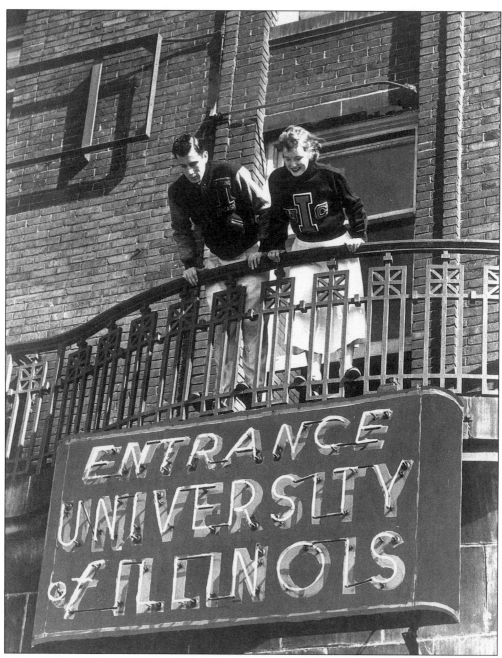

Chicago Undergraduate Division (CUD) students Howard Grosky and Mary Meixer lean from the balcony above the Navy Pier entrance in 1954. Unlike the Navy, which used the Pier for training purposes in WWII, the University only occupied part of the Pier, which became an increasing problem due to student enrollment pressures. Other tenants included the Chicago Police Department's traffic division, the North Pier Terminal Company, and several military detachments. (UIC photograph by Thomas Fehr.)

Three

"ON THE ROCKS"
CHICAGO UNDERGRADUATE
DIVISION AT NAVY PIER
1946–1965

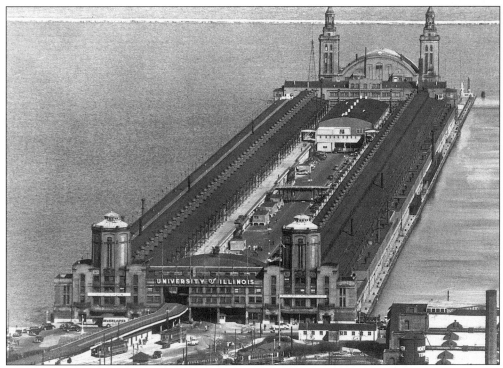

Navy Pier, completed in 1916, extended 3,000 feet eastward into Lake Michigan. The university leased the north half of the Pier in 1946 as a temporary facility to accommodate students on the G.I. Bill. Students enjoyed the college's lake location and "algae-covered walls," nicknaming the campus "Harvard on the Rocks." (UIC.)

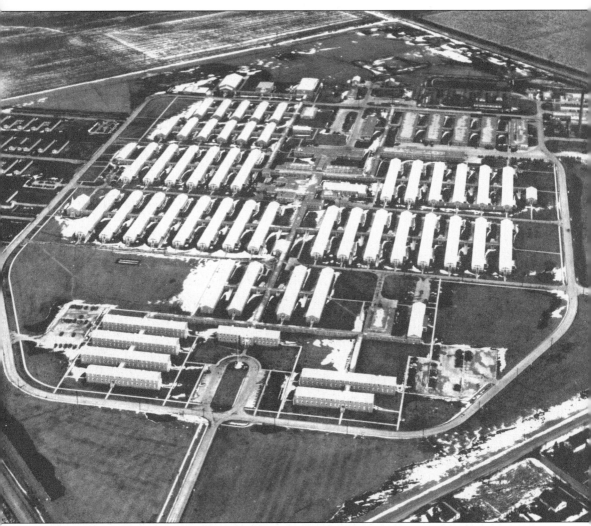

After World War II, the University of Illinois committed itself to educating all qualified Illinois students, a commitment which necessitated temporary expansion to accommodate the large influx due to the G.I. Bill. Seen above is the wartime Mayo Hospital complex outside Galesburg, Illinois, which the University took over for its Galesburg branch. The university closed it in 1949, after the first wave of G.I. Bill students. (UIUC.)

Psychologist George Stoddard, right, assumed the university presidency in 1946. He was internationally recognized for his work on intelligence testing, and distinguished himself on the U.S. Commission to UNESCO. His outspoken political positions clashed with Trustee President Park Livingston, left. Livingston was elected board president in 1943, at age 36, the youngest in Illinois history. He served a total of 24 years on the board, ten as president, and also headed the Medical District Commission, serving on the Commission from 1941 until his death in 1999. (UIUC.)

Board of Trustees President Park Livingston dedicates the Navy Pier campus during opening ceremonies in October of 1946. (UIC photograph by Thomas Fehr.)

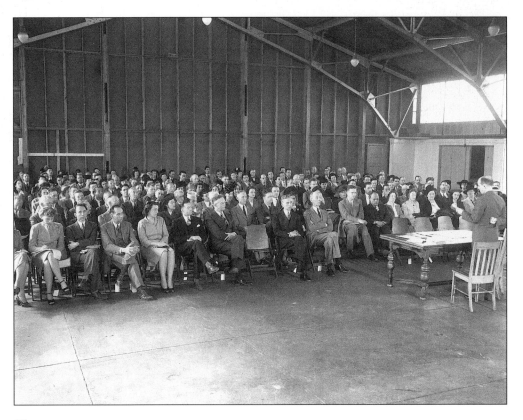

Charles Caveny, education officer and director of Naval education on Chicago's Navy Pier, was a Navy captain during World War II. He went from teaching in the Navy to the deanship of the Chicago Undergraduate Division in 1946, serving until 1961. He led several other Naval officers on to the university's staff, including Dean of Men Warren Brown. Caveny addressed the CUD faculty (below) on the first day of classes, October 1946. (UIC photograph by Thomas Fehr.)

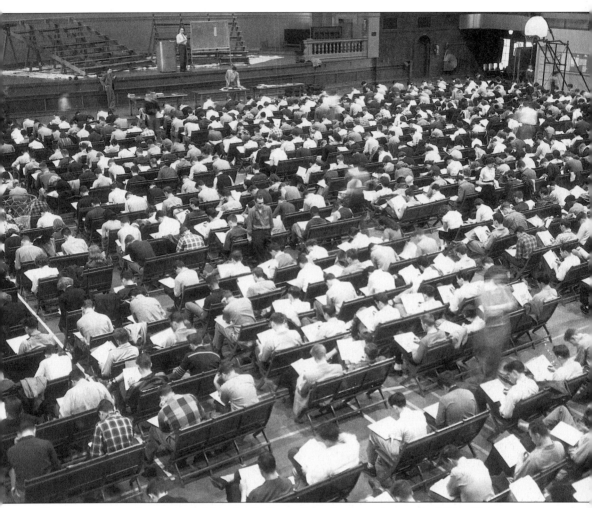

Entrance examinations were held in the "ballroom" on the far eastern end of Navy Pier, as were the many dances and social events. Note the basketball net on left, as the ballroom also served as one of two gymnasiums. (UIC photograph by Thomas Fehr.)

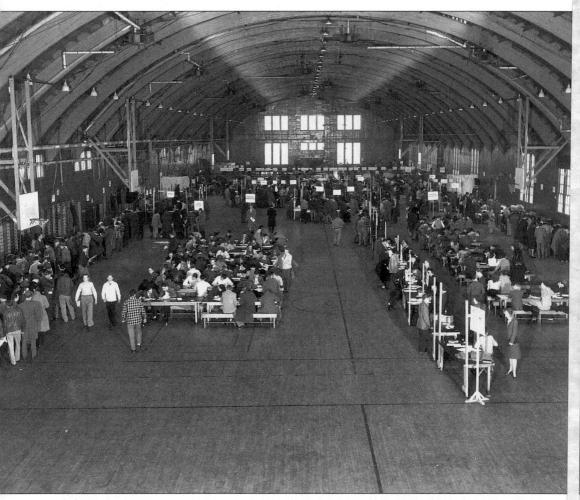

Navy Pier Registration was held in the large gymnasium just to the southwest of the Pier, shown here in October of 1946. During the school year, physical education classes were held in this, the "world's longest gymnasium." Although many of the almost 4,000 enrolled students were G.I.s, there were also many civilian students in the first classes. (UIC photograph by Thomas Fehr.)

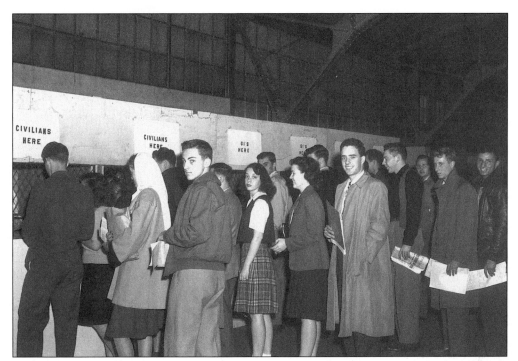

With the G.I. Bill, the Federal government paid for tuition and books, and provided a small living allowance. Notice the separate registration lines for Civilians and G.I.s. (UIC photograph by Thomas Fehr.)

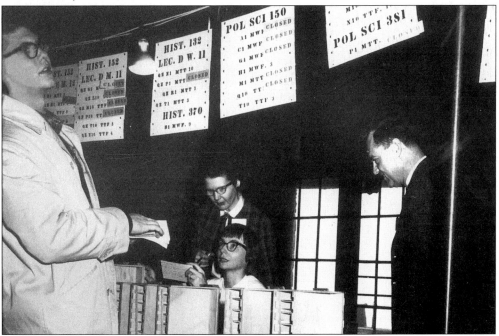

History Professor Shirley Bill, standing, registers students. Registration was first-come, first-served, as seen by the numerous closed classes. The history department later named its teaching award after Professor Bill. (UIC.)

The security staff on the Pier was affectionately called "Our Pier Protectors."

The G.I. Bill also provided a book allowance, as seen in these signs in the Pier bookstore. Notice the minimum order was 50¢ on the G.I. Bill. (UIC photographs by Thomas Fehr.)

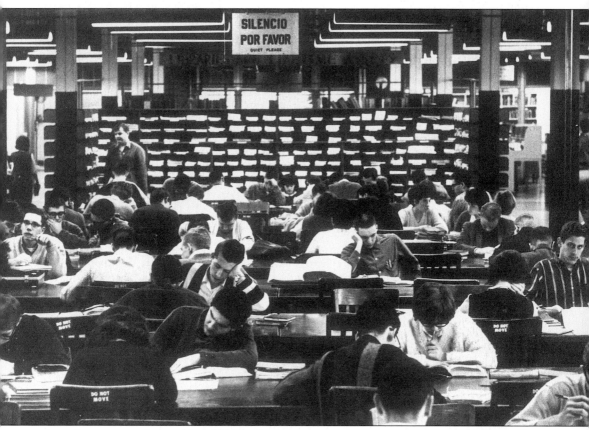

When classes opened in 1946, the library at Navy Pier held just 10,000 volumes. The Pier was quite overcrowded, and as a commuter campus, students had few alternatives for study space between classes. (UIC.)

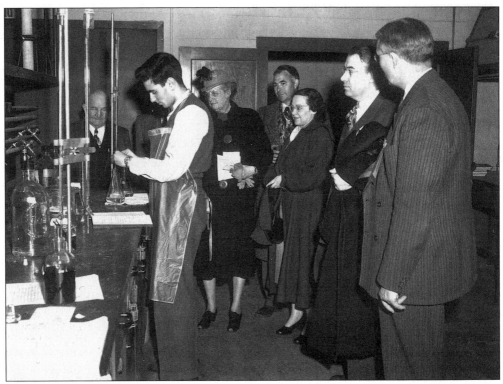

The Citizens Committee, made of prominent Chicagoans and university alumni, lobbied to create a four-year campus in Chicago. Here they tour a chemistry lab during a Pier Open House. (UIC photograph by Thomas Fehr.)

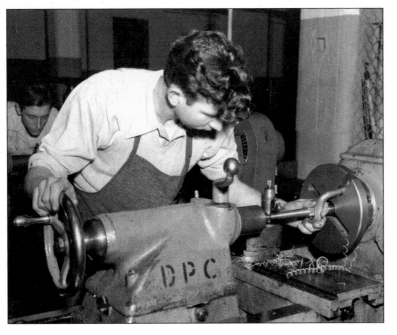

Sophomore George Eckenstater, 22, of West 71st Street, works on a project in metalurgy. The "DPC" on his lathe stands for Defense Plant Corporation, as much of the equipment on the Pier was war surplus. (UIC photograph by Thomas Fehr.)

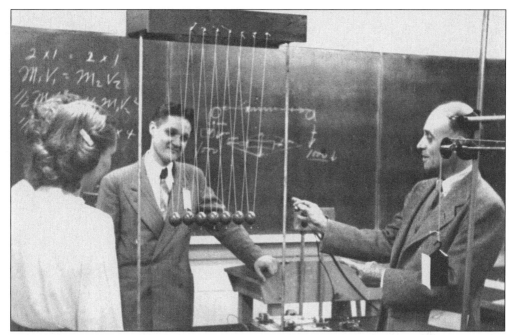

Assistant Professor of Physics Ogden Livermore was one of the most popular teachers in physics, later establishing a small scholarship for students after retiring in 1967. (Photograph courtesy of Physics Department.)

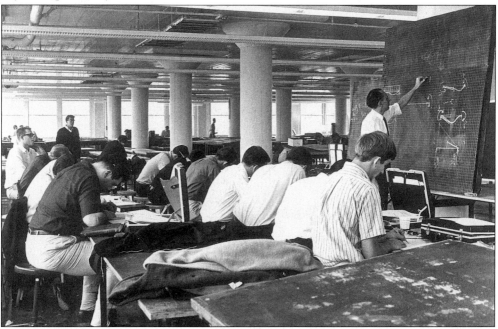

Pictured here is an engineering class in the early 1960s. If the classroom was on the inside of the Pier, students had to listen to trucks unloading at the warehouses; if an outside classroom, students were interrupted by the pile drivers building the filtration plant. As one student remembered, "when they'd let off with that ship's horn, everybody would jump about three feet off the ground." (UIC.)

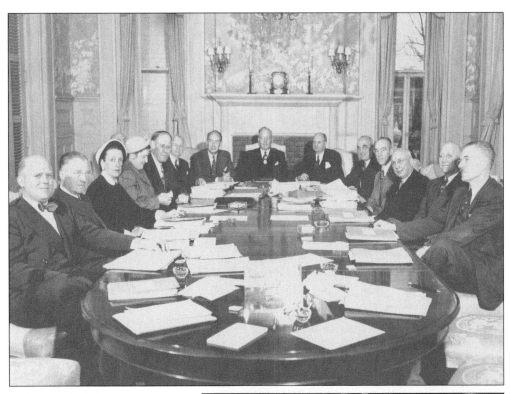

Board of Trustees met at Governor Adlai Stevenson's mansion in April of 1950, above. That year, they voted to continue the Navy Pier branch, but only as a two-year school. In response, students began agitation for a four-year university in Chicago, including the "Mile-long petition" in March 1953, which pressured the board and state to expand the Navy Pier campus into a full university. (UIUC top, UIC right.)

60

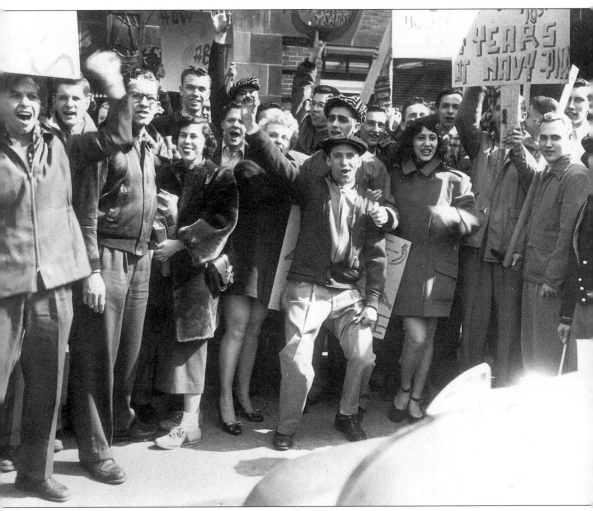

Students formed a "Quad Council" to continue agitation for a four year campus. In 1936, a young state legislator named Richard J. Daley introduced a resolution calling for a University Campus in Chicago. This later became House Bill 108, passed in 1951, which mandated the University to create a permanent four-year campus in Chicago. (UIC.)

While Navy Pier heavily emphasized technical education, the arts were also prominent in the late 1940s, such as this modern dance group, "Orchesis." (UIC photographs by Thomas Fehr.)

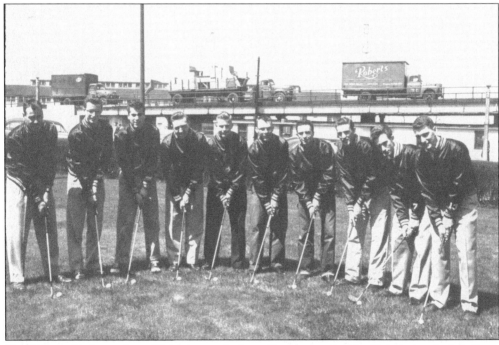

The Chicago Undergraduate Division even had a golf team, coached by Dick Rader, far left. From 1953 to 1967, hall-of-famer Rader led the team to a 178 and 31 record. Note the entrance ramp leading to the Pier warehouses in the background.

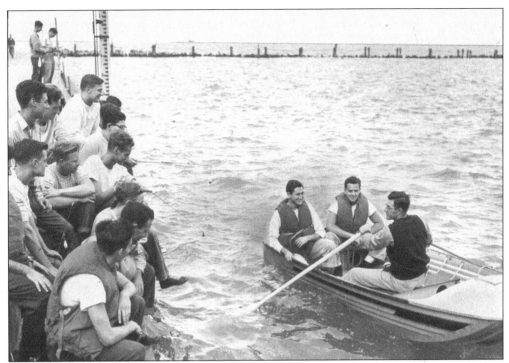

Physical education often had to be imaginative in its use of space. Pier faculty, such as Leo Gedvilas (with oars) taught swimming, boating, and fishing in the lake, and other instructors used Chicago's park system for outdoor archery classes. (UIC photographs by Thomas Fehr.)

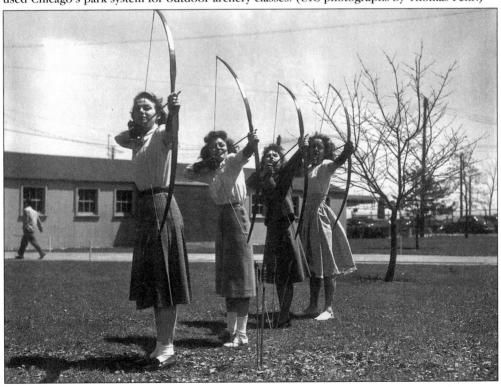

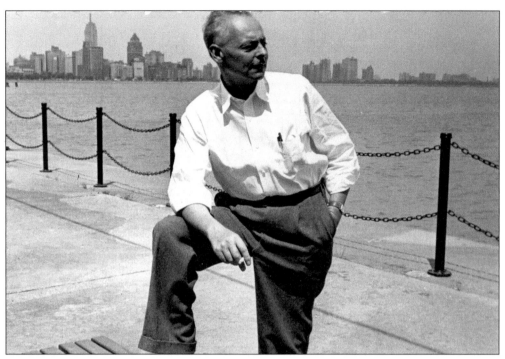

Architecture Professor H. Allen enjoys a break between classes. Navy Pier provided spectacular views of the Chicago skyline, although students were occasionally distracted, such as when an amphibious plane crashed and sank outside the library window.

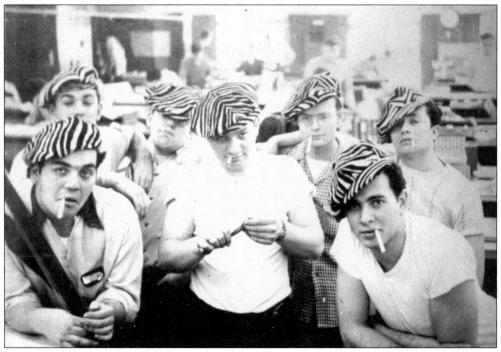

Pictured here are Pier architecture students, known as the "Zebra Kings." (Photos by Mel Markson.)

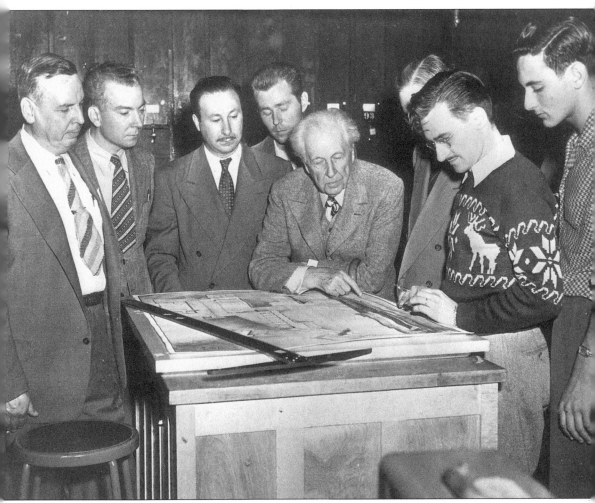

In October of 1948, Frank Lloyd Wright visited Navy Pier to examine student work and consult with U of I architecture professors McEldowney, Shopen, and Gutnayer. During the years at Navy Pier, architecture gradually expanded into junior-year courses, providing a strong foundation for later expansion into a full five-year program. (UIC.)

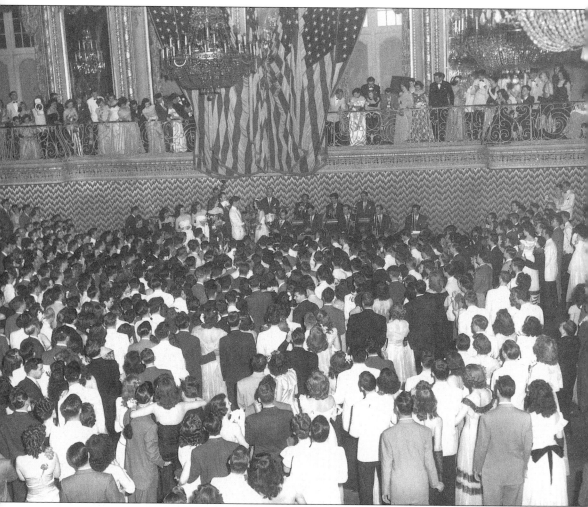

The university hosted a number of dances throughout the year, with two or three, including a Farmer's Ball, Springtime Magic, the Tropicana Dance and frequent "Coke Dances," scheduled each quarter. Here, the king and queen are crowned under the flags at the Palmer House ballroom at the Spring Formal, held March 22nd, 1948. (UIC photograph by Thomas Fehr.)

The first homecoming at Navy Pier was held on November 11, 1951, when "sweater girl" Marlene Crocker was elected Miss Navy Pier.

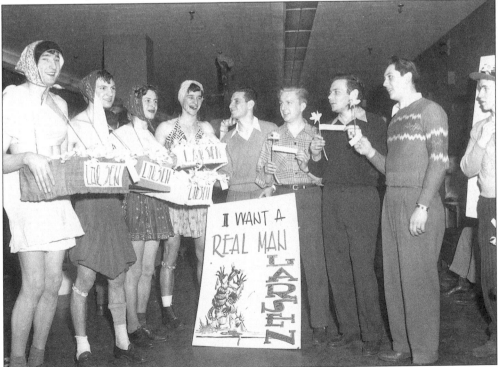

Student government elections were hotly contested in the early years at the Pier. Here, students "in drag" campaign for sophomore student body presidential candidate Larsen in March of 1948. (UIC photograph by Thomas Fehr.)

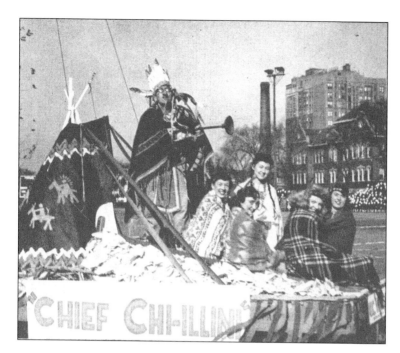

Students celebrate homecoming in November of 1951. The Chicago branch had its own version of Urbana's Chief Illiniwek, as seen in this homecoming float.

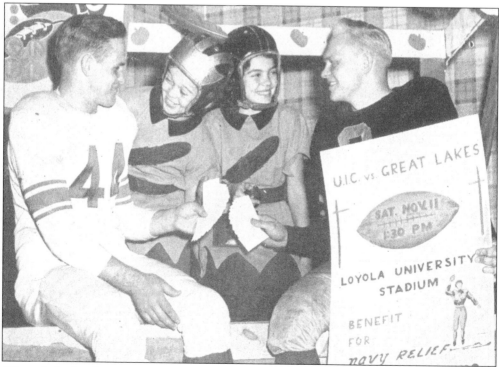

Although the first homecoming in 1951 was "one of the most outstanding displays of enthusiasm ever rallied at the Pier," UIC unfortunately lost the match.

Head football coach Walter Versen discusses strategy with team co-captain Hal Nemoto (right) in 1954. Versen was head coach from 1952 to 1963, finally retiring from university athletics in the 1990s. Nemoto graduated from Urbana, returning to the Pier to serve as head coach from 1968 to 1973, when football was dropped as a sport. Both are members of the UIC Athletic Hall of Fame. (UIC.)

The UIC acronym has a long history, dating back to the late 1940s at Navy Pier. This photograph is from homecoming, 1951. (UIC.)

10¢
CAGO AND SUBURBS
5c ELSEWHERE

CHICAGO SUNDAY
SUN-TIMES

CITY

Copyright, 1953, by Field Enterprises, Inc.

.l. 6, No. 43 Average net paid circulation for last 6-month A.B.C. period **600,954** **SUNDAY, JULY 26, 1953** TELEPHONE ANdover 3-4800 DEarborn 2-3323 **136 Pages—5 Sections**

RED GRANGE MOTION BOOTS STODDARD OUT

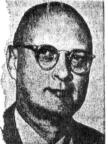

GEORGE D. STODDARD

By Burnell Heinecke
Sun-Times Staff Correspondent

CHAMPAIGN—George D. Stoddard has resigned as president of the University of Illinois. One of his top aids also was shifted.

His resignation followed a no-confidence vote, taken at the request of Harold (Red) Grange, U. of I. football immortal and an anti-Stoddard member of the board of trustees since his election in 1950. The trustees voted 6 to 3 that they lacked confidence in Stoddard's administration.

Stoddard will give up his office, duties and residence on the Champaign-Urbana campus Aug. 31. Lloyd C. Morey, university comptroller, was tabbed by the nine-member board to

step in as acting president until a successor is found.

Stoddard's salary, however, will continue through Feb. 1, 1954, because of accumulated leave allowances.

Details of the caustic dispute that lead to Stoddard's resignation were shrouded in secrecy. Stoddard himself said he was confident it centered in the controversy over the so-called cancer drug, krebiozen, which has embroiled the university and some of its top officials in a public debate.

Coleman R. Griffith, provost of the state tax-supported university and a close friend and associate of Stoddard, also was forced out of his

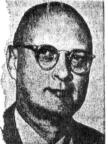

Continued on Page 3

HAROLD (RED) GRANGE

Truce Hour Is At Hand

TOO MUCH TO BEAR
L[it]ified 94-year-old East Berlin woman finds food gift too much
^she breaks into tears at special relief center in Berlin. Mayor
O[r]smann of a West Berlin borough tries to comfort her. Woman
1/he oldest relief applicants allowed to cross Iron Curtain border.

PANMUNJOM (UP)—Reliable sources said that a Korean truce probably will be signed at 2 p.m. Sunday Korea time (midnight Saturday Chicago time). Twelve hours later the shooting will cease, ending a police action that has become one of the most costly wars in history.

South Korea's President Rhee has renewed his pledge not to obstruct the armistice, and an informant said Rhee was "very much pleased" by U.S. Sec. of State Dulles' reply to Rhee's message of Friday.

Persistent reports said it was Kim Il Sung, the North Korean leader, who had delayed final arrangements for the formal truce-signing ceremony. These reports said that Kim had balked at attending a public ceremony at Panmunjom.

Nam, Harrison Would Sign
If he does not attend, the armistice probably will be signed first by the chief truce negotiators, Lt.Gen. William K. Harri-

son and Gen. Nam Il, in a joint ceremony here. Then the English, Chinese and Korean language texts would be flown to Tokyo and Pyongyang for signature by the opposing commanders.

The signing at Panmunjom, even if by the armistice delegates alone, will be the official signature from which the timing of the cease-fire will start. American and Communist liaison officers met five times Saturday.

American officers from 8th Army headquarters began moving into place along the front line Saturday to insure that the guns are silenced and the troops,

particularly the South Koreans, withdraw on schedule.

Within 72 hours after the truce signing, the opposing forces will pull back two kilometers each, leaving a 2½-mile "neutral" zone between them.

PWs To Start Home
Almost at the same time, "Operation Big Switch" will be-[.] bringing home through Panmunjom the first of 3,000 Americans, 7,000 South Koreans and about 2,000 other United Nations prisoners, mostly from the British Commonwealth and Turkey.

Some will get their first breath of freedom in three years. Ships

Continued on Page 2

8 Czechs Flee Reds In Homemade Tank

Story On Page 2

On Friday night, July 24, 1953, at around midnight, the Board of Trustees voted "no confidence" on President George Stoddard. While one cause appeared to be the Krebiozen controversy, the principal reason for his ouster was political differences between Stoddard and the board. Of all the Chicago newspapers, only the *Sun-Times* led with the Stoddard dismissal; the others led with the truce in Korea.

70

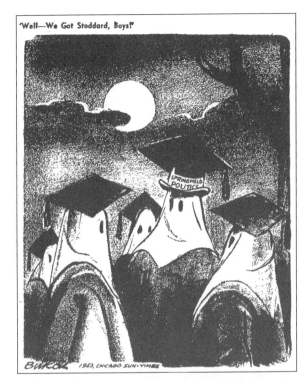

'Well—We Got Stoddard, Boys!'

BURCK 1953, CHICAGO SUN-TIMES

Several days after the firing, the *Sun-Times* ran this cartoon (right), expressing their view of the politics behind Stoddard's dismissal. In the photograph below, university comptroller Lloyd Morey, far right, signs his loyalty oath as acting president before several trustees and Provost Henning Larsen, far left. Morey was the first U of I alumnus to serve as president, and had worked for the university since 1911. (UIUC.)

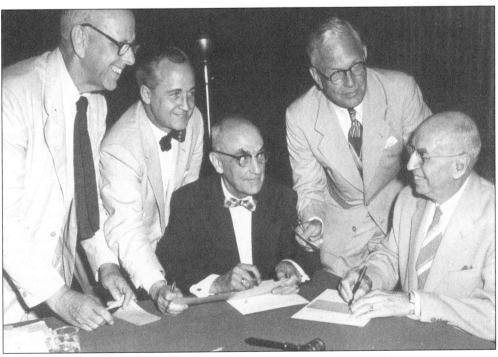

In 1955, David Dodds Henry assumed the university presidency, serving until 1971. Henry came from Wayne State in Detroit, where he had built a municipal college into a state-supported university. In the interim, Henry had served as provost of New York University. Part of his mandate was to create an urban university in Chicago. (UIUC.)

Henry tried to mobilize public opinion behind university expansion, warning that the incoming wave of college-age students in the mid-1960s would overwhelm the university. Illinois's biennial budget process and the Stoddard firing set back university expansion by at least five years. These factors forced an even more frantic pace once funding for the Chicago campus was approved, and the site was chosen in 1961. (UIUC.)

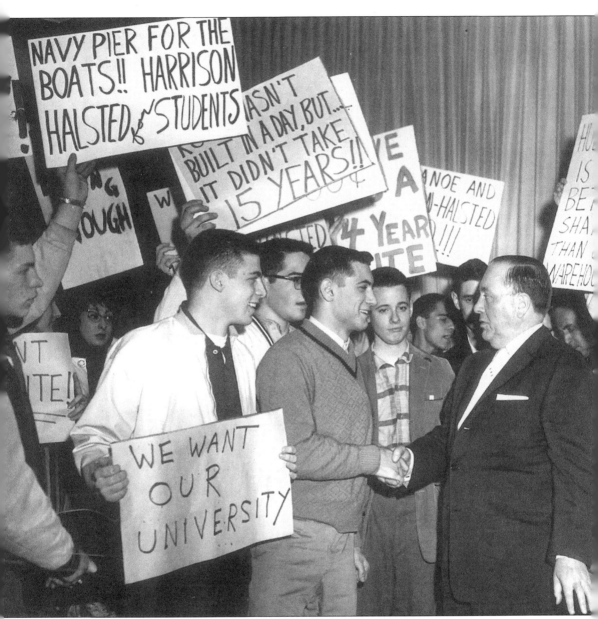

Navy Pier students were strongly in favor of a permanent campus, as they met with Chicago's Mayor Richard J. Daley in April of 1961. (Photograph courtesy of *Chicago Sun-Times*.)

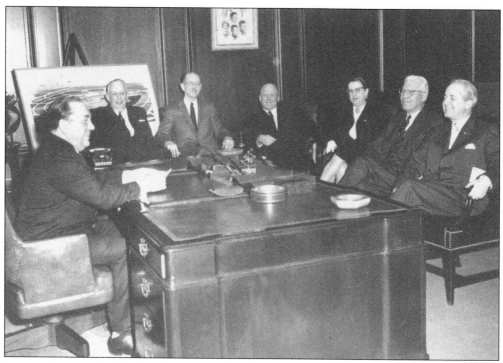

In an effort to win site location within the Chicago city limits, Mayor Daley, meeting with President Henry and the Board of Trustees in 1959, offered to equal the costs of any suburban site. (UIC OPA.)

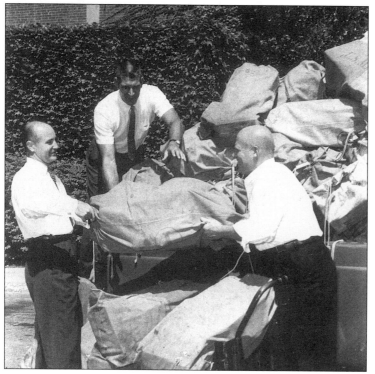

Funding was the critical issue behind any university expansion. One bond issue failed in 1958, so the 1960 election was critical. In a bipartisan effort, Daley and universities throughout the state pushed a $195 million bond issue, with $50 million earmarked for a Chicago campus. Joseph Begando, then assistant to President Henry, left, and Park Livingston, right, unload promotional literature of the bond issue campaign in September of 1960. (*News-Gazette* photograph.)

Four

CREATING A PERMANENT CAMPUS

1956–1965

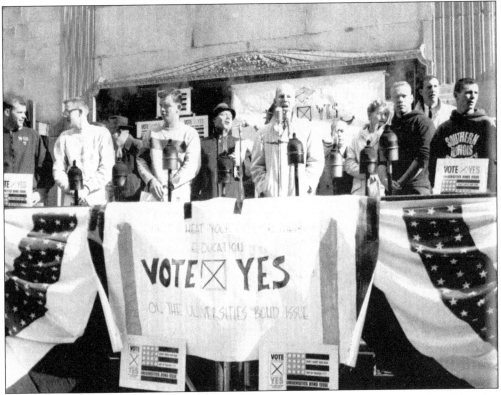

As part of the campaign to create a permanent campus, each Illinois university sent torch-bearing runners throughout the state to raise public consciousness. They adopted the slogan, "Don't Cheat Your Kids On Their Education." (UIC LHS.)

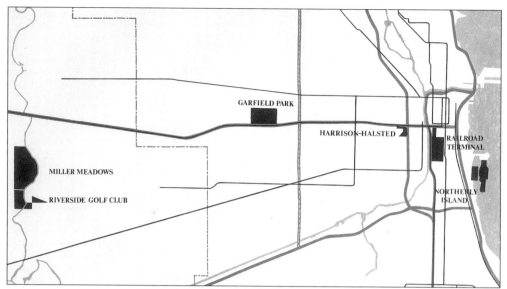

One of the most important campaign issues concerned the location of the campus. The university administration favored a suburban site at Miller Meadows, while Mayor Daley preferred a location at the Railroad Terminals. Three other possible sites included the Riverside Golf Club, Garfield Park, and Northerly Island, the location of the Meigs Field Airport. When the Railroad Terminal site proved unavailable, Daley, in early 1961, offered Harrison-Halsted, then a federal urban renewal site, as a compromise. The Harrison-Halsted site was easily accessible to public transportation and the new expressway system. (UIC.)

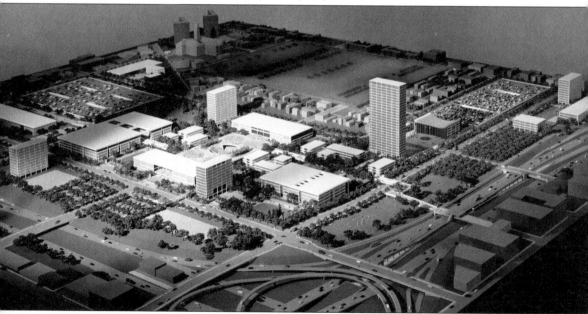

Shown above is the master planning model in September of 1961. Note the original design of the Art and Architecture building (center), the auditorium to the right of University Hall, the size of the library and laboratories, and the humanities graduate complex (on the far right alongside the Eisenhower expressway). These were either never completed or remained on the drawing board. (UIC, courtesy of Skidmore, Owings, and Merrill.)

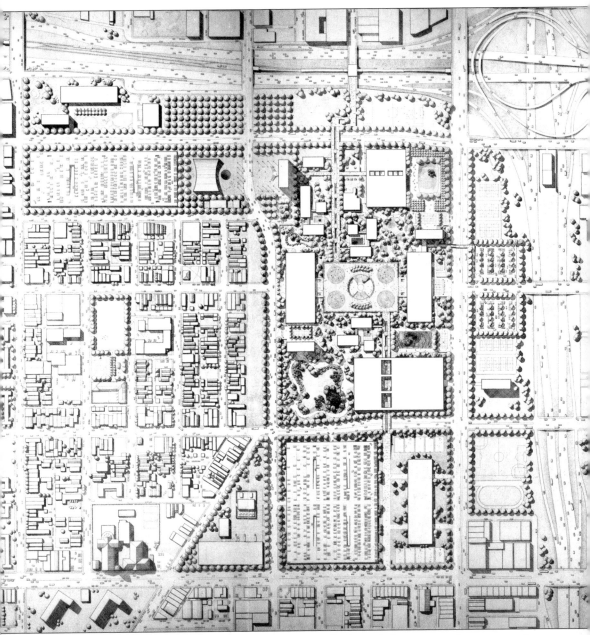

The architectural firm of Skidmore, Owings, and Merrill planned the campus, above, preparing alternative site plans for a university of approximately 32,000 students by 1970. (UIC, courtesy of Skidmore, Owings, and Merrill.)

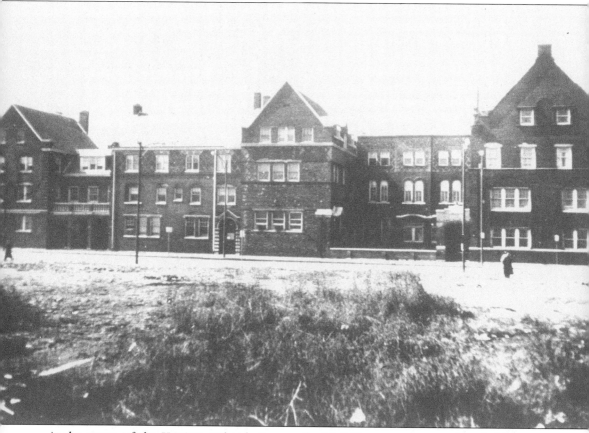

At the center of the Harrison-Halsted site was the Hull House settlement, founded by Jane Addams and Ellen Gates Starr in 1889. Within a decade after its founding, Hull House had grown to a complex of thirteen buildings. This view is from the east, across Halsted street. From left to right, the buildings housed the Immigrants' Protective League, the Juvenile Protection Association (with residential apartments above), the Butler building, the original Hull mansion with a small courtyard in front, and the Smith building on the right, at the corner of Halsted and Polk. (UIC.)

Shown here is the site plan of the Hull House settlement. The original Hull Mansion is in the lower right of the diagram. By 1960, the settlement's board was struggling over its place in a changing neighborhood, although many residents and supporters had a clear vision for its place in the city. Below is the Near West Side Planning Board, one of the first citizen-planning boards in the country. Board initiative helped establish the Harrison-Halsted district as a federal urban renewal site, which unintentionally provided land clearance money for Circle Campus. (UIC.)

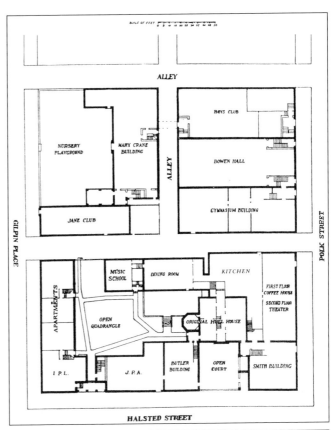

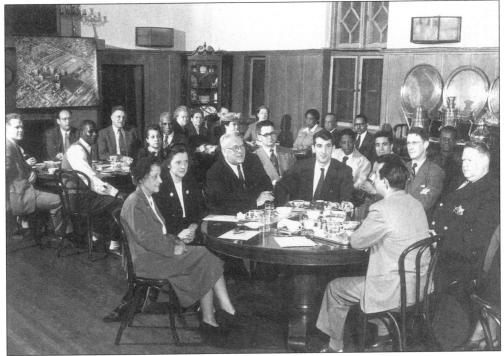

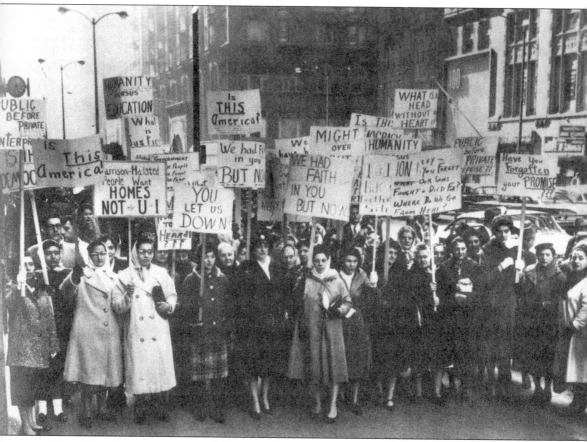

Mayor Daley's announcement of the Harrison-Halsted site led to wide-spread protests from the neighborhood. In February of 1961, women from the neighborhood, led by Florence Scala, marched in front of City Hall to protest the decision. Most of their husbands remained discreetly in the background, as many worked for city agencies. Even though he didn't work for the city, Scala's husband lost his bartending job as a result of his wife's association with the movement. (Photograph courtesy of *Chicago Sun-Times*.)

Florence Scala, opposite, stands in front of the remnants of the Hull House complex in 1963. Behind her stands the dining hall, which is being moved adjacent to Hull House prior to its restoration as a museum. Mrs. Scala challenged the Democratic machine as a write-in candidate for the alderman seat, but was unsuccessful. She still lives in the neighborhood. (Photograph courtesy of *U. S. Catholic*.)

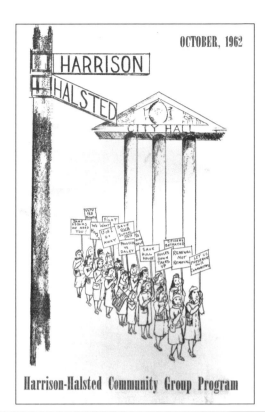

Public protests proved ineffective, so the women formed the Harrison-Halsted Community Group in order to oppose the site decision in the courts. At left is a brochure designed to raise money for court challenges. The community group filed suit in both federal and state courts, but in May of 1963, the U.S. Supreme Court refused to hear their appeal. The way was then cleared for the construction of Circle Campus. (Courtesy of Florence Scala.)

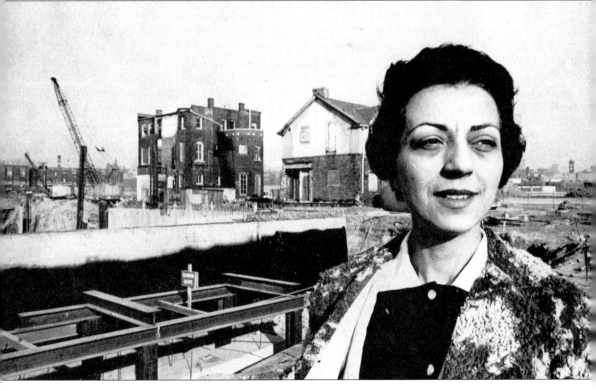

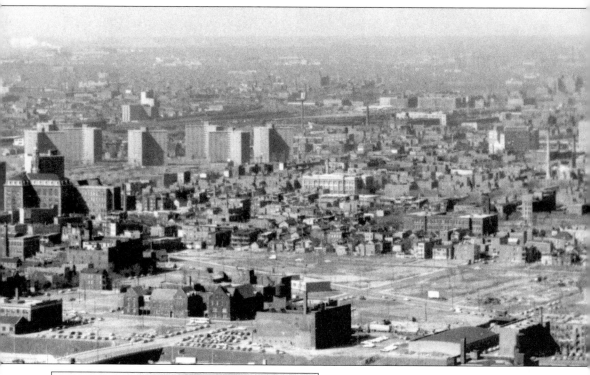

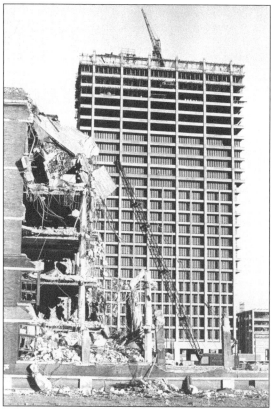

The Hull-House complex, in left foreground above, was one of the last to be demolished, after almost the entire site was cleared. The University later renovated the Hull Mansion, along with the dining hall, turning them into a museum along Halsted Street. (UIC.) At left is the construction of University Hall. (UH photograph courtesy of *Chicago Sun-Times*.)

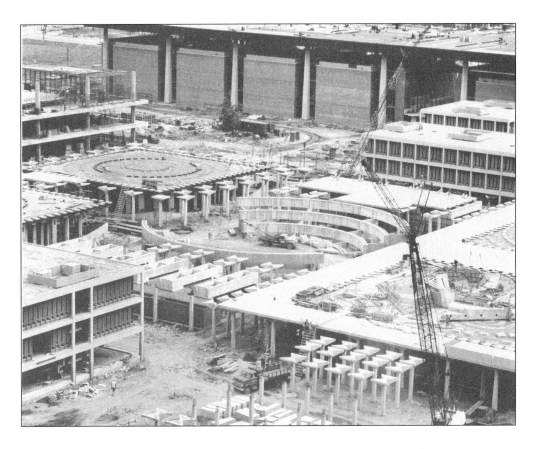

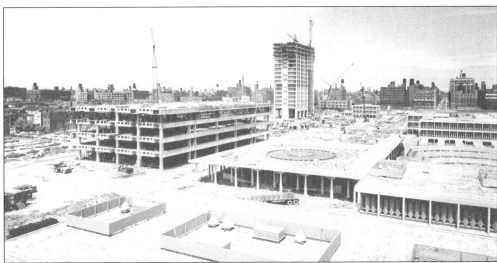

The construction of Circle Forum, above, reveals the "butterfly columns" used to support the walkways. The bottom view shows the lecture center and library under construction, with University Hall in the background. (Orlando Cabanban, photographer.)

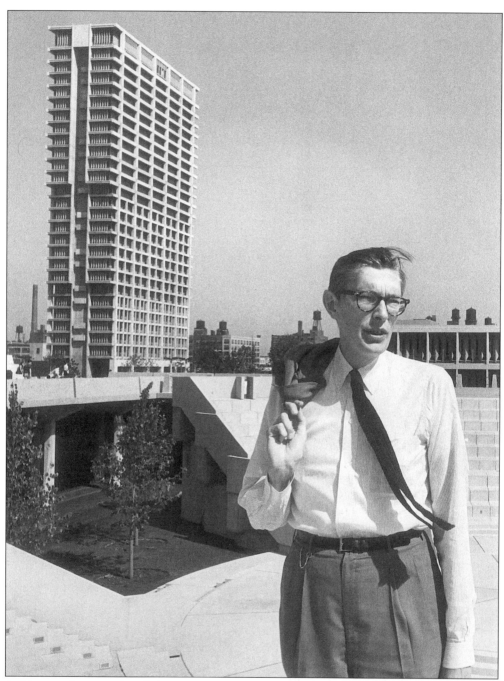

Architect Walter Netsch, of Skidmore, had designed the U.S. Air Force Academy in Colorado Springs, then led the team that created Circle Campus. His blueprint resembled a "drop of water," the center of which was the Circle Forum. The surrounding rings consisted of lecture halls, classroom clusters, the library, student center, laboratories, and offices. In order to accommodate the projected 32,000 students in a limited area of approximately 100 acres, Netsch designed a circulation system of second-story walkways. The design later won an award from the American Institute of Architects. (Orlando Cabanban, photographer.)

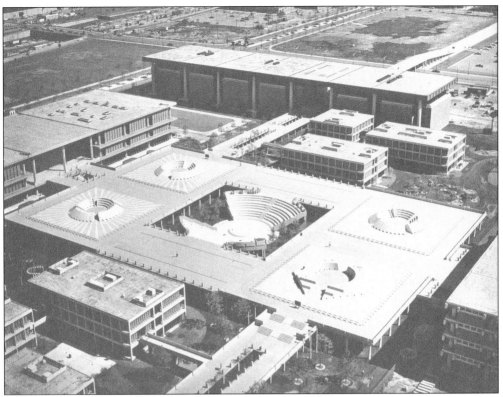

The "Great Court" consisted of the Forum and four excedras on the roofs of the lecture halls, with the science and engineering labs in the background. (Orlando Cabanban, photographer.)

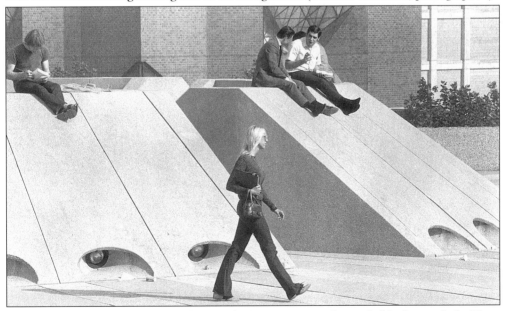

Visible here is one of the four "excedras" in the Great Court on the roof of the lecture halls. Three of the four were stepped inside to be used for classes, with the fourth called by the architect at the time a "girl-watching excedra." (George Philosophos, photographer.)

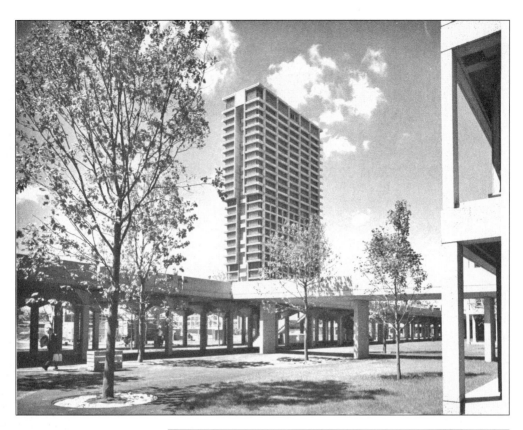

Shown here is a view of the second story walkways, above, with University Hall in the background. At the right is the library, showing the staircase leading up to its second floor entrance. On ground level is one of the small buildings designed to store chairs for students to sit outside. (UIUC.)

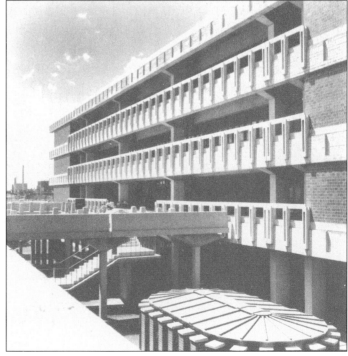

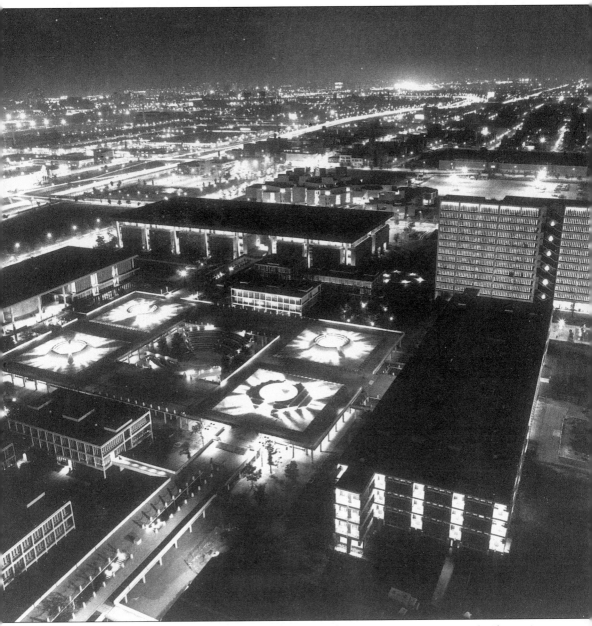

Netsch designed elaborate lighting for the campus, although an arrangement with Chicago's other universities limited evening classes for the first decade of Circle's existence. (Orlando Cabanban, photographer.)

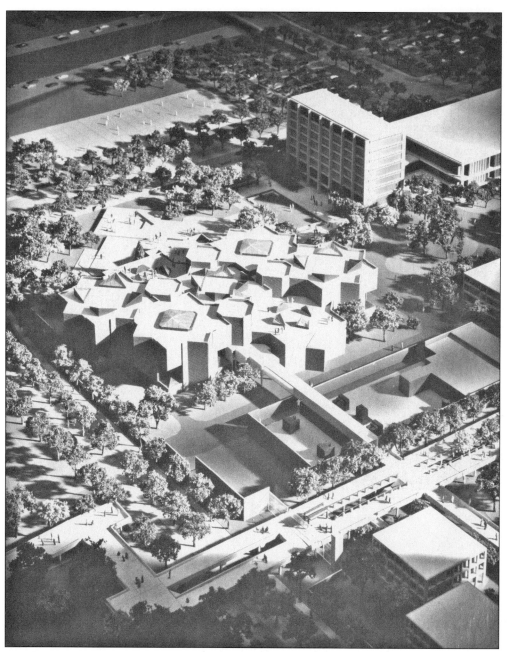

By phase two of campus construction, Netsch had changed his fundamental design, experimenting with a pattern he called the "field theory," based on rotated squares. Above is the model of the controversial Art and Architecture building, his first field theory building. Unfortunately, funding ran out before the building was half finished. Opposite top is the blueprint of the field theory Behavioral Sciences Building, with construction below. (Model at UIUC; opposite top, courtesy SOM; bottom UIC.)

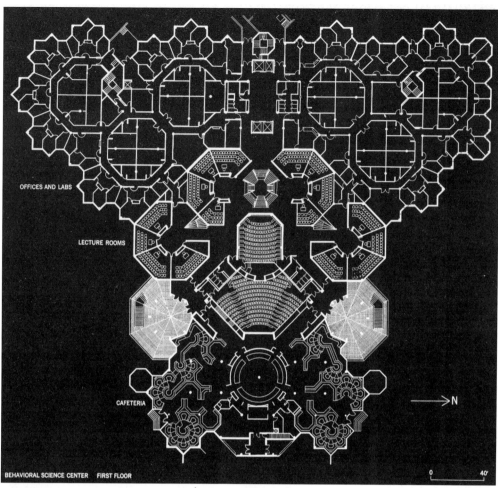

OFFICES AND LABS

LECTURE ROOMS

CAFETERIA

→N

BEHAVIORAL SCIENCE CENTER FIRST FLOOR

0 40'

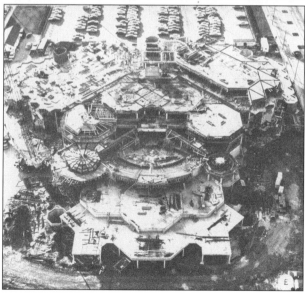

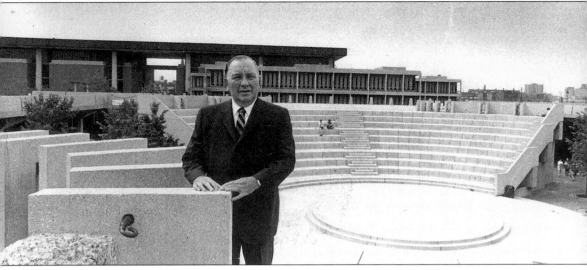

Mayor Richard J. Daley worked for almost 30 years to make his vision of a publicly supported university in Chicago a reality, and he considered it his "greatest achievement" in his 21 years as Chicago's mayor. (Photograph courtesy of *Chicago Sun-Times*.)

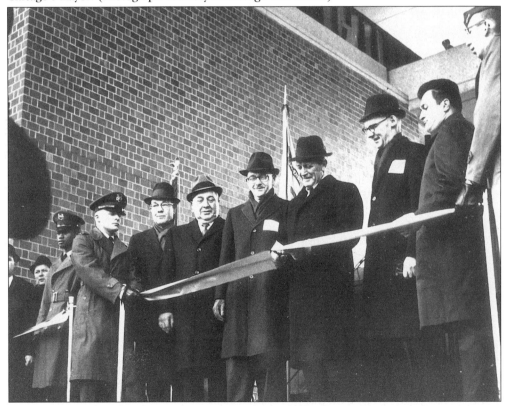

Governor Otto Kerner cuts the ribbon on the walkway at the Science and Engineering Laboratory at the opening of Circle Campus on February 22, 1965. The temperature hovered around ten degrees, as Chancellor Parker, Mayor Daley, President Henry, and Board President Howard Clements look on. (UIC.)

90

Five

"CIRCLE CAMPUS"
1965–1982

In the late 1960s, Circle Campus was one of the fast growing universities in the nation, with enrollment increasing from 5,000 to almost 18,000 within five years. Large class sizes, along with a desire to attract research-oriented faculty, led planners to build numerous large lecture halls in the Great Court. (UIUC.)

As a commuter campus, Circle tried to accommodate students by creating numerous lounge and study spaces, such as the Montgomery Ward Lounge on the second floor of the Chicago Circle Center. (UIUC.)

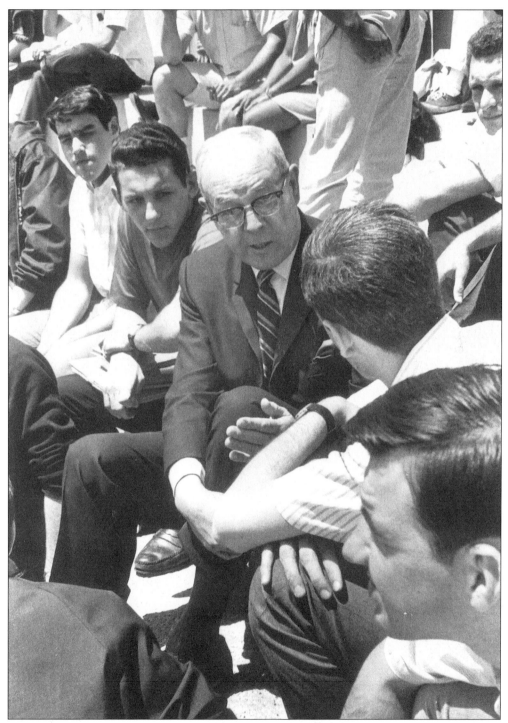

Norman Parker, a mechanical engineer from Urbana, had chaired the space and facilities planning committee in the late 1950s, then moved to Chicago in 1960 to head the development of Circle Campus. Parker concentrated on the physical side of the campus, leaving most faculty recruitment to the college deans. (UIC.)

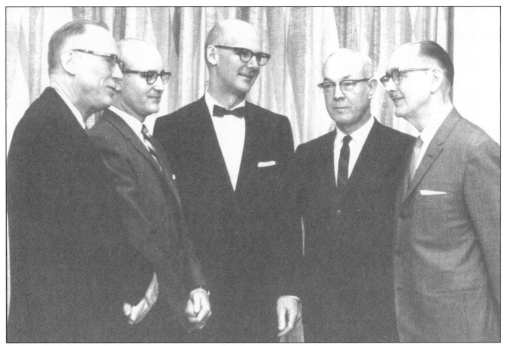

The major administrative leadership behind the university's expansion in Chicago in the 1960s appears as follows (left to right): Provost Lyle Lanier, Medical Center Chancellor Joseph Begando, Board President Howard Clements, Circle Chancellor Norman Parker, and President David Henry. (UIUC.)

University Provost Lyle Lanier served from 1960 through 1972, and was an enthusiastic supporter of Dean Terrell's efforts to build a strong research-oriented faculty at Circle Campus, with rapid expansion into graduate programs. (UIUC.)

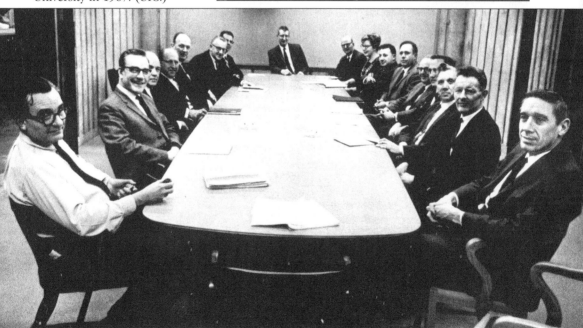

In order to create the intellectual infrastructure of Circle Campus, Psychologist Glenn Terrell was brought in as Dean of Liberal Arts and Sciences in 1963. As Dean, Terrell appointed 16 LAS department chairs, emphasizing research and graduate training rather than teaching in Circle departments. Terrell became the Dean of Faculties in 1965, and later left to become president of Washington State University in 1967. (UIC.)

Pictured in this 1966 photograph are LAS department chairmen, with LAS Dean Stanley Jones at the head of the table, Dean of Faculties Terrell at right, and Dan McCluney (later LAS dean) at left. (UIC.)

95

Circle students were often the first in their families to attend college, and Circle provided the opportunity through low tuition and scholarships. Future CNN anchor Bernard Shaw, for example, received a scholarship in 1966 from the "Chicago Ambassador Program" to spend the summer in South America. Shaw has since endowed several scholarships for UIC students. (UIC.)

Circle Campus sought to use the latest technology in instruction, such as these "reading machines." The lecture centers included a "teletorium" with televised lectures, although professors were reluctant to use them. (UIC.)

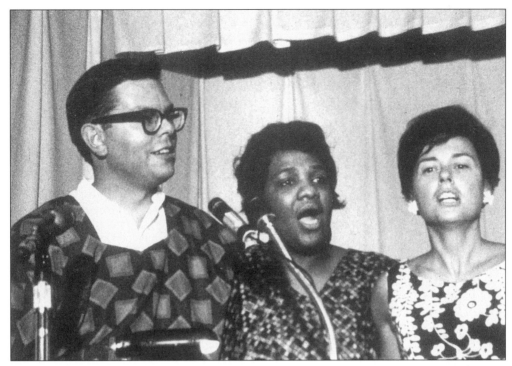

James Holderman, above left, was the Vice Chancellor for Administration in the late 1960s, and interpreted Circle's "Urban Mission" to mean enhancing ties with the Black community. Dashiki-clad, he receives an award as he leaves the university to head the Illinois Board of Higher Education. He and members of the West Side Organization are shown here singing "We Shall Overcome" in the spring of 1969. (UIC OIR.)

At right is a student cartoon from 1967. By this point, Circle Campus was the fastest growing campus in the nation, though by 1969 it would suffer severe setbacks as funding was curtailed during the governorship of Richard Ogilvie. (UIC.)

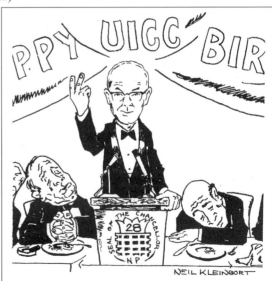

. . . AND WITH PLANNING AND FORESIGHT THIS UNIVERSITY—IN ONLY TWO YEARS—HAS BECOME AS OVERCROWDED AND UNDERFINANCED AS SCHOOLS FIFTY TIMES ITS SENIOR.

Sept 20-21

FRESHMEN WEEKEND 1969

Each Fall would see one or two "freshmen weekends," when several dozen prospective students would travel to a summer camp for a weekend of games, activities, and orientation exercises.

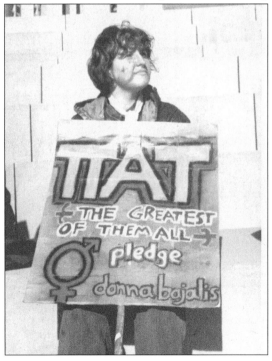

πAT
←THE GREATEST OF THEM ALL→
pledge
donna bajalis

Circle Campus was a commuter campus, and students needed to be especially creative in developing a "campus life." Pictured here is πAT, one of the first co-ed "fratorities," and among the most active in the 1960s. It combined service with frequent social events to build a sense of community on an often alienating commuter campus. (Photographs courtesy of Warren Allen.)

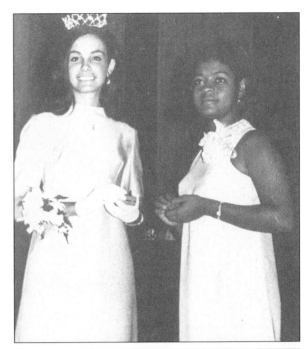

Josephine Fortunato, homecoming queen of 1968, receives a gift from Randi Tolmaire, right, homcoming queen of 1967. (UIC.)

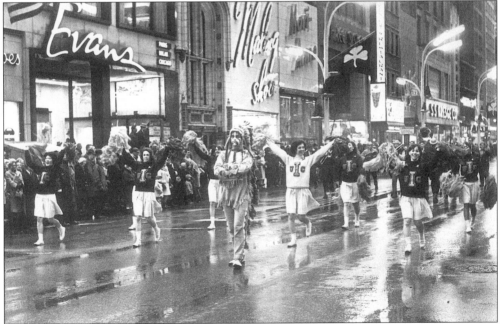

Participants march in Chicago's St. Patrick's Day Parade, 1965. Circle Campus had opened only a few weeks before, but the band still was able to march behind the Chief and the cheerleaders, with their UIC letters. (UIC.)

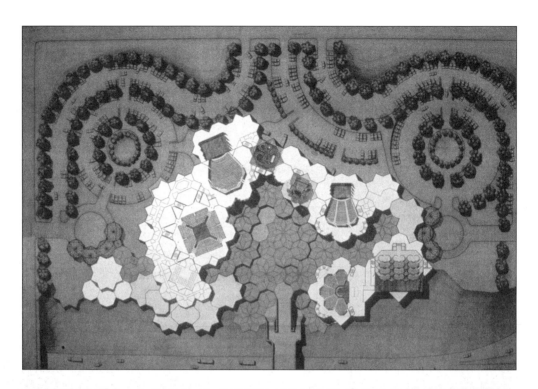

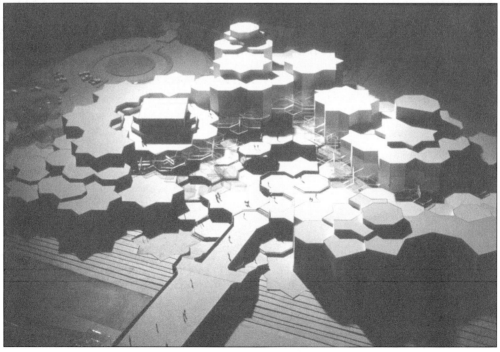

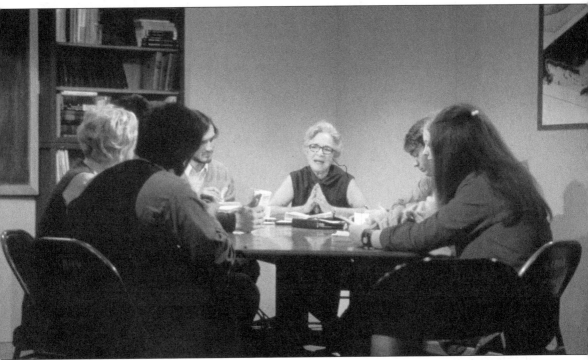

The "first lady of the American stage," Helen Hayes, gave an advanced acting seminar during the 1968-69 school year. Hayes had connections with a prominent Chicago foundation which the university hoped would partially fund the theatre complex. On Ms. Hayes's right is Michael Gross, who later starred in the television comedy *Family Ties*. (UIC.)

"Project Y," opposite, was the name given to a "secret" planning project to create a theatre complex for Circle Campus, north of the Eisenhower Expressway between Morgan and Halsted streets. Walter Netsch designed the project in 1968-69, using his "field theory" to create a series of concert halls and theatre spaces after the model of New York's Lincoln Center. At top is the site plan, with educational theatres on the left, concert halls along the top, and smaller theatres and an opera house towards the right. Below is the conceptual model of the site, looking north with the pedestrian bridge across the expressway. Unfortunately, none of Project Y was built due to funding cutbacks. (Project Y photographs courtesy of Walter Netsch.)

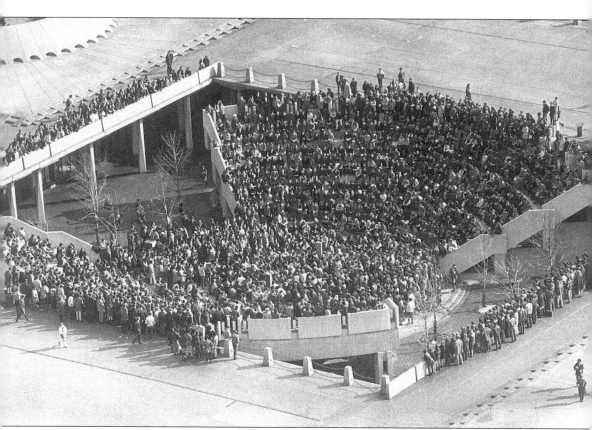

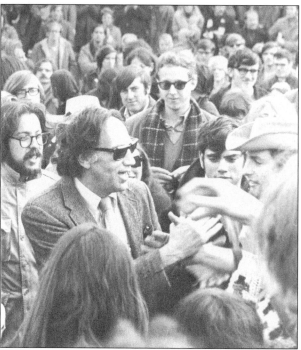

Because Circle Campus was on the quarter system, classes were not in session during the 1968 Democratic Convention in August, although fallout from the rioting continued to agitate the campus well into the following year. The Chicago Seven conspiracy trial began in the fall of 1969, and continued for four and a half months. That fall, defense attorney William Kunstler appeared in the Circle Forum to help shape student opinion on campus in favor of the larger anti-Vietnam war movement. (George Philosophos, photographer.)

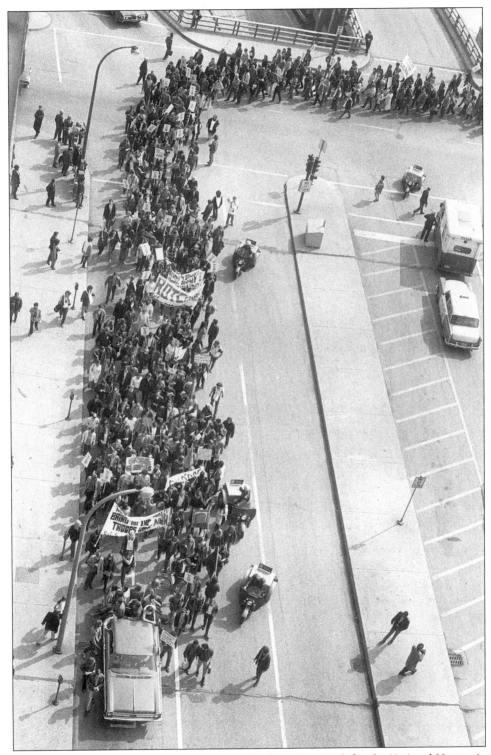

In April of 1970, UICC and UIMC students marched on Grant Park for the National Moratorium against the War in Vietnam. (George Philosophos, photographer.)

STRIKE! On April 30, 1970, President Nixon ordered U.S. troops to invade Cambodia, setting off a fire-storm on university campuses throughout the nation. The Kent State killings on Monday, May 4th led to massive student strikes, including one at Circle Campus. (UIC.)

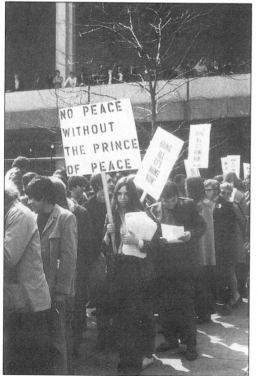

On the day of the strike, students had planned a religious rally in the Forum, and were overwhelmed by students protesting the Cambodian incursion. The religious rally and anti-war demonstrations combined in a picture of competing student activism. The Circle administration closed the campus for a week, and, at the suggestion of Dean of Students Oscar Miller (opposite bottom), opened the A&A building to student protesters. Circle students turned it into "Strike Center," coordinating student strikes at universities and high schools throughout the city, with a rally in Grant Park on Saturday, May 9th. Miller's actions probably saved the campus from police or national guard occupation, as happened at the Urbana campus. (UIC.)

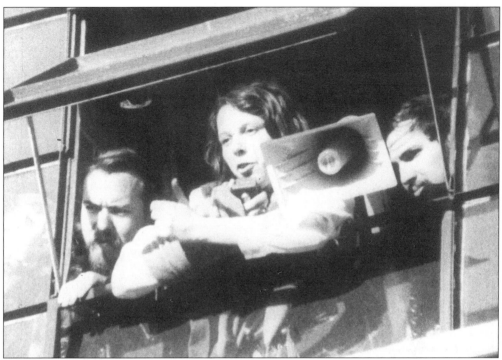

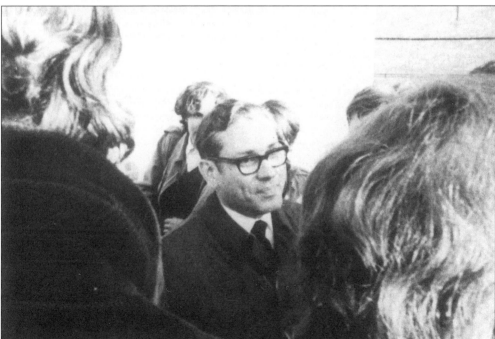

On Wednesday, May 6th, dozens of students occupied the Roosevelt Road Building (RRB) (top), which housed Circle's ROTC program. The protest was spontaneous and unorganized, and that night, over forty students were arrested by university and Chicago police for trespassing. Below, Dean Miller talks with students outside RRB during the strike. Both photographs are stills from a 16mm film. (UIC OIR.)

In order to expand the curriculum, students and some Circle faculty created an ad-hoc "Alternate University," which offered classes in everything from Israeli Folk Dancing to "ROTC for Civilians." Most met in the late afternoons and evenings, when there were few regular classes. One philosophy course invited students to "Do your own thing for credit." The poster above is from the Winter 1971 timetable. (Courtesy Urban Historical Collection.)

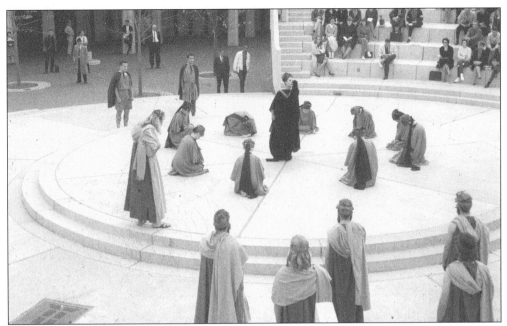

In October of 1965, the first play presented in the Circle Forum, fittingly, was *Antigone*. Performed in the original Greek, its leading role was played by Teresa Hatsopoulos. The director recruited some of the cast from nearby Greektown, and other parts were played by international UICC students. (Photograph by Laurette Kirstein, UICC advisor to foreign students.)

This photograph features the chorus in *Oedipus the King* by Sophocles, directed by William Raffeld in November of 1976. For the first five years, dramatic productions were held at the 11th St. Theater, until a theater was constructed on campus. (Courtesy of theater department.)

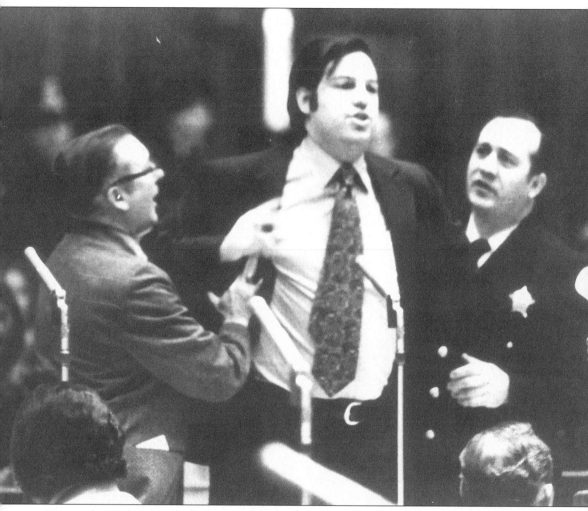

As an urban university, Circle Campus was closely tied to the political situation of the city, often in contrasting ways. Political scientist Dick Simpson was alderman of the 44th Ward from 1971 to 1979, served on the transition teams of Mayors Jane Byrne and Harold Washington, and later ran for Congress. A reformer, Simpson clashed frequently with Mayor Richard J. Daley. In the above photograph, Simpson is being forcibly seated on order of Daley during City Council hearings. (Photograph courtesy of Dick Simpson.)

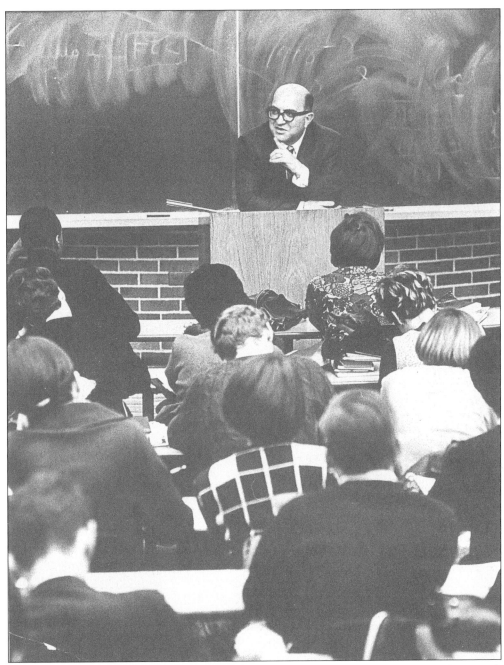

While Simpson was the opponent of the Democratic Machine, his colleague, Professor Milt Rakove, was the consummate insider, serving as loyal precinct captain and even running for minor offices on the Machine's slate. Rakove was close to Alderman Vito Marzullo, who was instrumental in creating the Illinois Medical District. Rakove would later publish two insider accounts of the machine: *Don't Make No Waves, Don't Back No Losers* (1975) and *We Don't Want Nobody Nobody Sent* (1979). Simpson and Rakove team-taught a popular seminar on Chicago politics in the 1970s. (UIC OPA.)

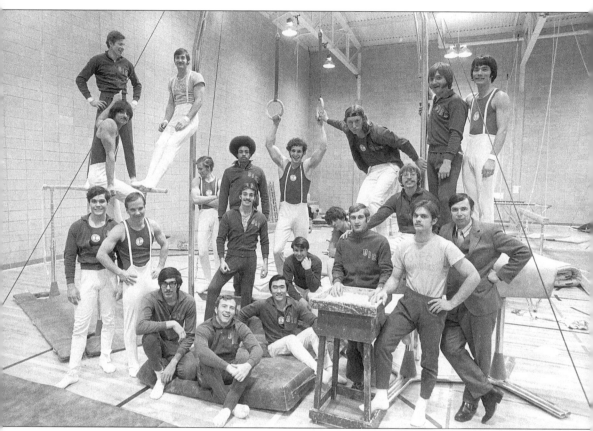

The 1971 men's gymnastic team poses in the Physical Education Building (PEB) (above). UIC has a strong tradition of success in gymnastics, including two national championships in 1978 and 1979 as well as over 40 All-American gymnasts. (George Philosophos, photographer.)

Opposite below is a slice of Chicago basketball history, as the Meyer family poses amidst the construction of the UIC Pavilion. DePaul University head coach Ray Meyer is flanked by his two sons, DePaul assistant coach Joey Meyer on his right, and UICC head coach Tom Meyer on Ray's left. Due to delays in construction, the game between DePaul and Circle was actually played at the Rosemont Horizon. The University of Illinois at Urbana was originally tabbed to play the Pavilion opener, but they declined the honor. (UIC Athletics.)

Chuck Lambert pulls in a rebound against a player from Illinois Institute of Technology at PEB. UICC played there until moving into the Pavilion for the 1981-82 season. Lambert played until 1975, finishing as the school's leading rebounder and third all-time leading scorer. (UIC Athletics.)

At Navy Pier, the football team was called the "Chicago Illini," but changed their name to the "Chikas" at Circle Campus. Here, Chikas defender Alex Sigalos brings down his man during a 1969 game. The Chikas finished the year with a one and seven record. Due to lack of interest and funding, football ended as a UICC sport in 1973. (UIC.)

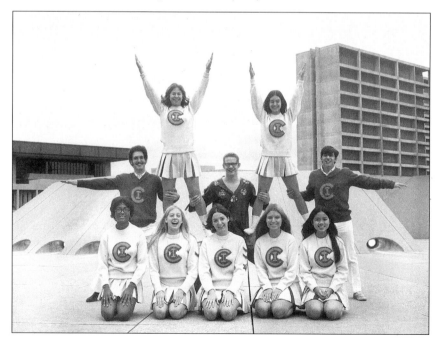

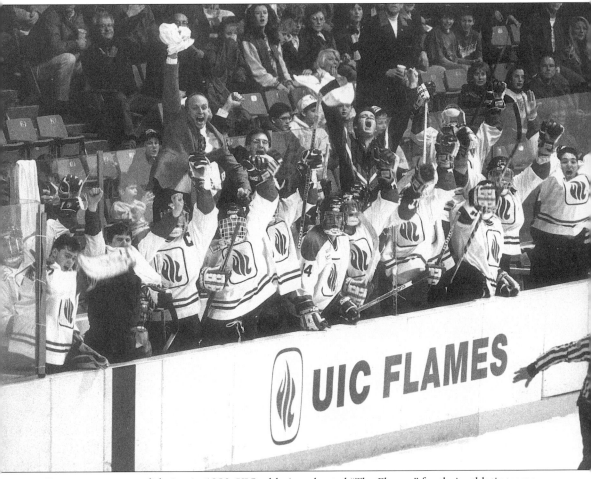

Upon campus consolidation in 1982, UIC athletics adopted "The Flames" for their athletic teams. The Flame logo actually spells out the letters "UIC." In the photo, the Flames bench goes crazy as the lamp is lit for another goal in the mid-1980s. Hockey was a major sport at UIC until the program was dropped in the Spring of 1996, in order to redirect resources towards the basketball program. (UIC Athletics.)

Opposite, the 1970 UICC cheerleaders pose on the upper level walkways in front of the Science and Engineering Offices. The cheerleaders performed in the Physical Education Building for basketball games, and at Soldier Field for football games. Note the logos reading "IC" (Illinois-Chicago) on their uniforms. (George Philosophos, photographer.)

John Corbally, left, served as Illinois's president from 1971 to 1979, coming from the presidency of Syracuse. Corbally led the University through difficult financial times, as Illinois suffered a series of economic downturns. Norman Parker, center, was succeeded as UICC Chancellor in 1971 by Warren Cheston, right. A controversial chancellor, Cheston alienated many by attempting to lower admission standards. He resigned under fire after only four years, calling himself "the wrong man in the wrong place at the wrong time." (UIUC.)

Cheston was replaced by Don Riddle, opposite right, seen talking to U of I President Stan Ikenberry, left. Riddle came from the John Jay College of Criminal Justice in New York City, and concentrated on reforming the administrative structure of Circle. Ikenberry, who succeeded Corbally in 1979, pushed the consolidation of the Chicago campuses, and was the driving force behind the creation of the UIC in 1982. (UIUC.)

114

Many individuals have stayed with the university throughout their entire careers, such as Stan Delaney, seen in this 1973 photograph. Delaney began as a student worker, and gradually advanced to become Vice Chancellor for Administration and head of the South Campus development project in 1999. (UIC.)

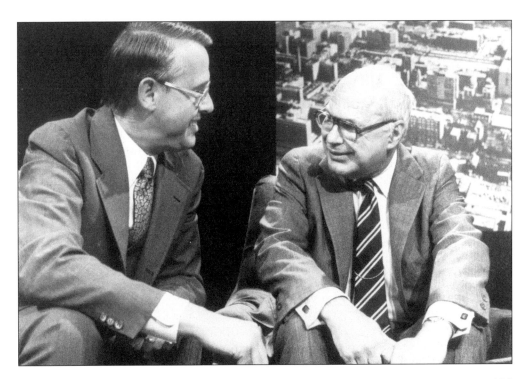

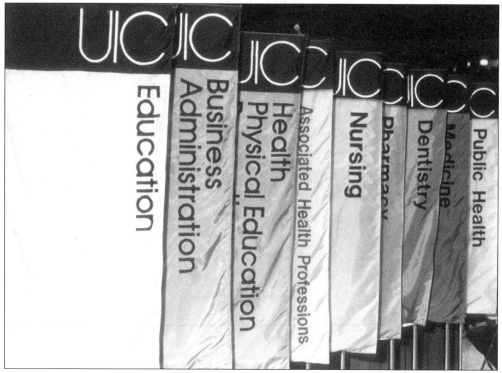

On September 1, 1982, the Medical Center and Circle Campus consolidated to form the University of Illinois at Chicago, making it a comprehensive research university. Displayed at commencement are the banners from all of the colleges on the east and west campuses. (UIC.)

Physicist Don Langenberg came from the National Science Foundation, becoming UIC's first chancellor early in 1983. Langenberg concentrated on the administrative consolidation of the two campuses, moving on in 1991 to become head of the University of Maryland system. (UIC OPA.)

Six

THE UNIVERSITY OF
ILLINOIS AT CHICAGO
1982–PRESENT

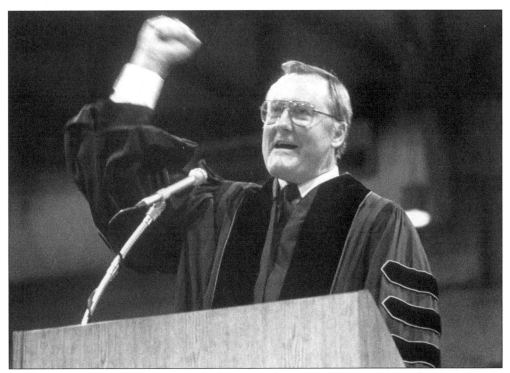

Illinois Governor James Thompson performs his duties as commencement speaker in May of 1987. Thompson was a student at Navy Pier, and a strong supporter of his two-year alma mater. (UIC.)

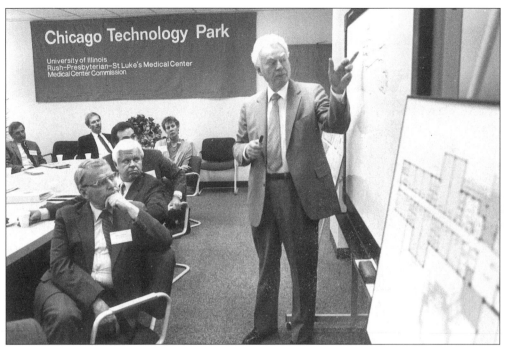

The Chicago Technology Park, on the western edge of the Illinois Medical District, was established in partnership with the University and Rush-Presbyterian-St.Luke's Medical Center as an incubator for start-up companies. Here, Ken Belford describes district building expansion. (UIC OPA.)

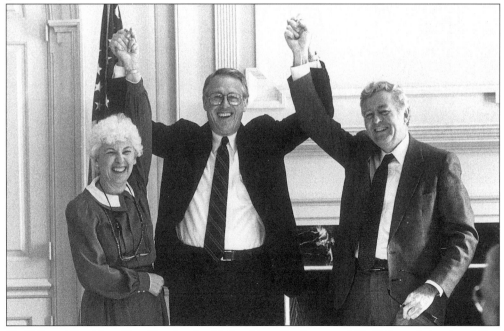

U of I Board President Nina Shepherd, with President Ikenberry and U of I Foundation head Alan Hallene, celebrate the "Campaign for Illinois" fundraising drive, which by January of 1985 had raised over $132 million for university research. (UIC OPA.)

Chicago Mayor Harold Washington is greeted by UIC students Christina Crocket (left) and Phyllis Ellis (right) on the anniversary of his Mayoral victory. In the background left is UICC alumnus Carol Moseley Braun, then Illinois state representative and later the first black woman U.S. Senator, and Congressman Ronald V. Dellums (D-Calif). (UIC OPA.)

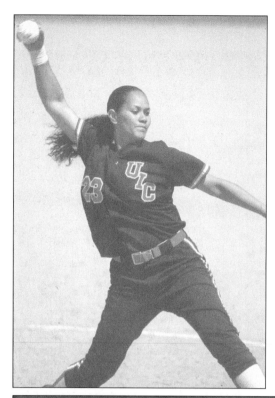

Samathana Iuli was UIC's first All-American softball player, and helped lead the Flames to the 13th ranking in the nation. By 1999, head coach Mike McGovern had produced one of the most successful programs in the country. (Steve Woltmann, photographer; courtesy of UIC Athletics.)

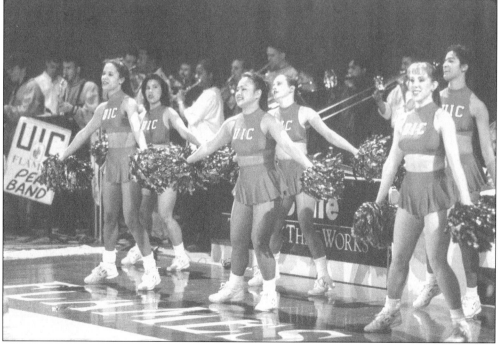

The Dancing Flames became national champions during the Universal Dance Association competition in 1996, with many later going on to professional careers. (Steve Woltmann, photographer; courtesy of UIC Athletics.)

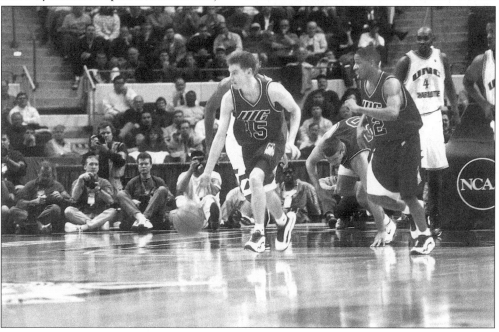

Head basketball coach Jimmy Collins was hired in 1996 after serving as assistant coach in Urbana for 13 years. In his first year, Collins was named Midwestern Collegiate Conference Coach of the Year. Collins concentrated on recruitment and program building, taking his team to the NCAA for the first time in the school's history in 1997-98, below. (Steve Woltmann, photographer; courtesy of UIC Athletics.) (Photograph below by Roberta Dupuis-Devlin for UIC.)

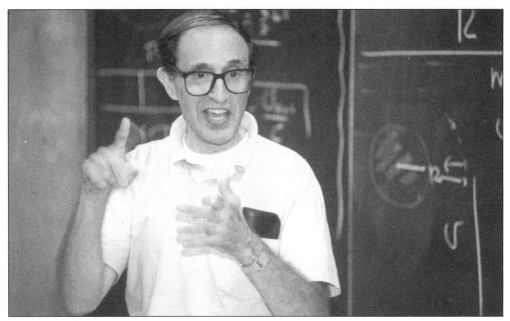

UIC Physics Professor Howard Goldberg was named the Carnegie Foundation's Professor of the Year in 1995. His research concentrates on high energy particle physics, and he has won several National Science Foundation grants, including one to create the Teaching Integrated Math and Science program for math and science education. (UIC OPA.)

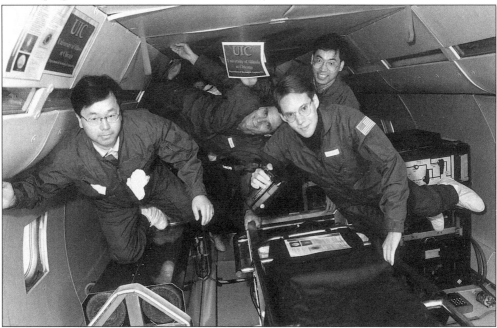

Mechanical Engineering Professor Mun Y. Choi and colleagues (Sam Manzello, Dr. Kyeong-Ook Lee, and Dr. Paul Ferkul) are pictured performing reduced-gravity combustion experiments aboard a NASA DC-9 Parabolic Trajectory Aircraft. Their department has performed research in numerous fields, such as MEMS, virtual reality, material science, bioengineering, heat transport phenomena, dynamics and control, and combustion and environmental science.

In the 1990s, UIC's College of Education inaugurated a new Masters degree program in South Korea. The inauguration team in Korea are, from left to right, Research Professor Herbert Walberg, Dean Victoria Chou, and Professor Ward Weldon. (Photograph courtesy of Herbert Walberg.)

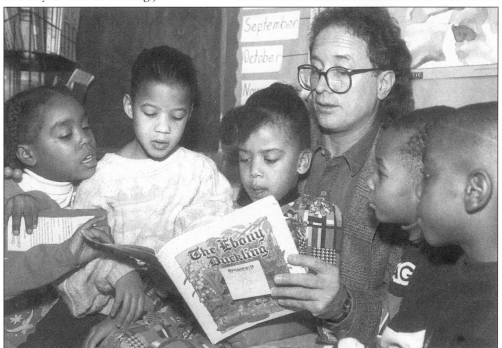

College of Education Professor and former 1960s radical Bill Ayers concentrates on the ethical and political dimensions of teaching, and helped land a $49 million foundation grant to improve the Chicago Public Schools. (UIC.)

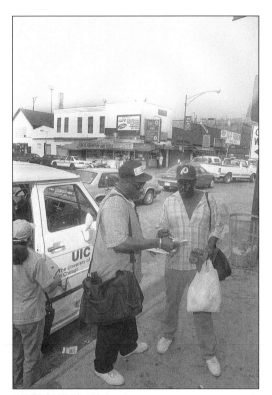

UIC's School of Public Health is active throughout the city, especially through its Community Outreach Intervention Project. Here, an outreach caseworker distributes anti-drug information on Halsted, just south of Maxwell Street, in the background. (Photograph courtesy of the School of Public Health.)

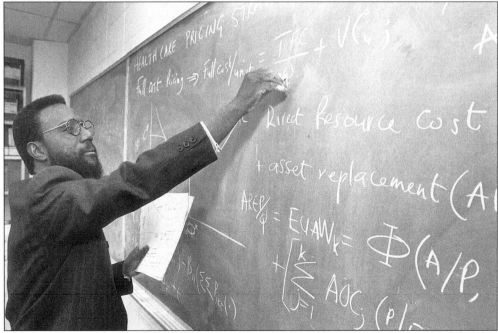

Professor Edward K. Mensah lectures to students on health policy and administration in the School of Public Health. The School focuses on numerous areas, such as occupational health, gerontology, health promotion, disease/injury prevention, health policy studies, and maternal and women's health. (UIC OPA.)

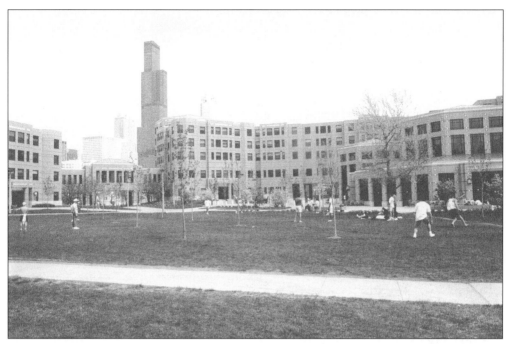

The opening of the East Side Residence Halls in 1988 marked a major change at UIC, as the first students moved onto the campus. The long-term goal is to house approximately 25% of all UIC students in university housing. (UIC.)

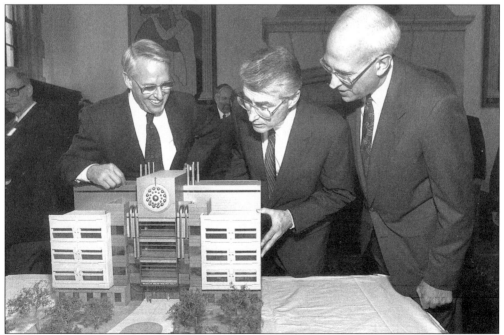

From left to right, President Ikenberry, Governor Jim Edgar, and UIC Chancellor James Stukel examine a model of the new Molecular Biology Research building. As chancellor, Stukel concentrated on campus beautification and research, leading UIC to Carnegie Research I status. He also began the Great Cities Initiative, which coordinates UIC's urban programs.

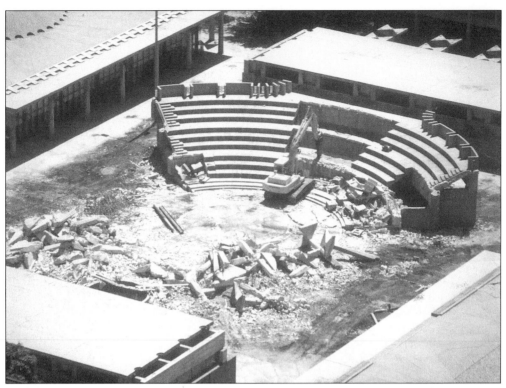

In 1993, the Campus Core revitalization began with the demolition of the Forum and removal of the walkways. The newly finished Campus Core opened in 1995, below, providing a greener and more appealing campus. (UIC OPA.)

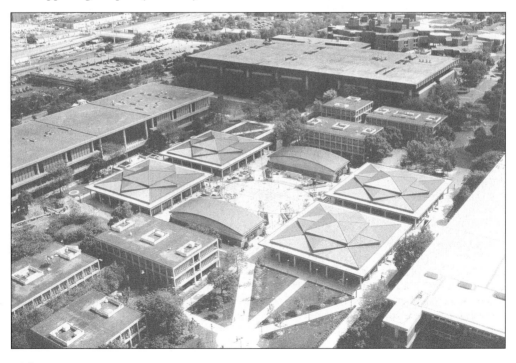

At right, Chicago Mayor Richard M. Daley meets with UIC Chancellor David Broski. Broski helped double research funding, oversaw the construction of the new Outpatient Care Center, and moved the South Campus development project towards completion. (UIC OPA.)

In October 1999, the UIC Library was dedicated to Richard J. Daley. His son, Mayor Richard M. Daley, read his father's words: "The role I played in establishing this campus is my greatest contribution to the life of the city." On the far left are Interim Chancellor Sylvia Manning and President James Stukel; immediately behind the Mayor is his mother, Mrs. Richard J. Daley. (UIC.)

ACKNOWLEDGMENTS

We would like to thank President James Stukel, David Broski, Art Savage, George Rosen, and others in the UIC administration; Jason Marcus Waak, Justin Coffey, Sean Labat, Jennie Murphy, and Frederick Beuttler of the UIC Historian's Office; Sonya Booth and UIC Public Affairs; Roberta Dupuis-Devlin and UIC Photographic Services; the UIC Alumni Association; Mary Ann Bamberger, Patricia Bakunas, Alan Kovac, and Douglas Bicknese of UIC Special Collections; Robert Adelsperger and UIC LHS Special Collections; Bill Maher and Bob Chapel of UIUC Archives; Burt Bledstein and the Near West Project; Marilyn Ratliffe and Arelene Flynn of the College of Pharmacy; the Colleges of Dentistry, Medicine, and Public Health; UIC Athletics; UIC Theatre; and Dr. Louis Boshes of the Neuropsychiatric Institute. Special thanks to Walter Netsch, Florence Scala, Orlando Cabanban, Dick Simpson, George Philosophos, Warren Allen, Birney Dibble, Laurette Kirstein, Herbert Walberg, and others, for their photographs.

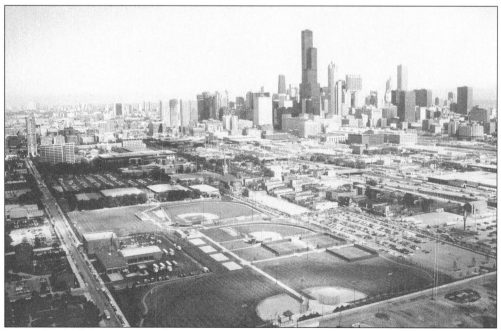

UIC's South Campus development plans are in the process of transforming Chicago's Near West Side as UIC seeks to become Chicago's leading urban research university.